Into Your Darkroom Step-by-Step

Dennis P. Curtin with Steve Musselman

Curtin & London, Inc. Somerville, Massachusetts

Van Nostrand Reinhold Company New York Cincinnati Toronto Melbourne

| Getting ready | Developing your negatives | Making proof sheets | Making enlarged prints |

Printed in the United States of America

Published in 1981 by Curtin & London, Inc. and Van Nostrand Reinhold Company 135 West 50th Street, New York, NY 10020, U.S.A.

Van Nostrand Reinhold Limited
1410 Birchmount Road
Scarborough, Ontario M1P 2E7, Canada

Van Nostrand Reinhold Pty. Ltd.
17 Queen Street
Mitcham, Victoria 3132, Australia

10 9 8 7 6 5 4 3 2 1

Library of Congress Cataloging in Publication Data

Curtin, Dennis, 1941-
 Into your darkroom step-by-step.

 Includes index.
 1. Photography—Processing.
2. Photography—Studios and darkrooms.
I. Musselman, Steve. II. Title.
TR287.C86 1981 770′.28′3 81-2800
ISBN 0-930764-24-2 AACR2

Interior design and cover design:
Susan Marsh

Illustrations: Carol Keller

Photographs: Step-by-step and equipment photos by Alan Oransky; all other photos by Dennis Curtin

Composition: The Heffernan Press

Printing and binding: Halliday Lithograph

Paper: 100# Patina, supplied by Lindenmeyr Paper Co.

Cover: Dynagraf Inc.

Acknowledgments

The following people have all been very supportive of the authors' efforts to develop this unique approach to darkroom work. For their help and guidance, the authors express their sincere gratitude while at the same time releasing them from any blame for the book's possible shortcomings:

Henry A. Froehlich and Charles Schneck of Berkey Marketing Companies for their encouragement and loan of equipment used to illustrate the step-by-step sequences.

Steve Hess of Saunders Photo/Graphic for his encouragement and support.

Ernst Wildi for his support in supplying Hasselblad equipment used to take the step-by-step and equipment photographs.

Alan Oransky for his excellent photographic work used to illustrate the equipment and step-by-step sequences.

Phil Davis at the University of Michigan for answering a series of questions on many of the technical aspects of film and paper processing.

Paul Mulroney of Eastman Kodak Company for taking the time to answer a number of specific questions about photographic chemistry.

Susan Marsh for a design that makes the material both attractive and yet easy to follow and understand.

Contents

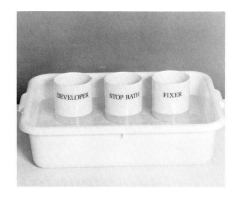
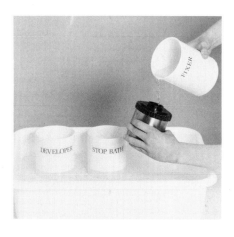

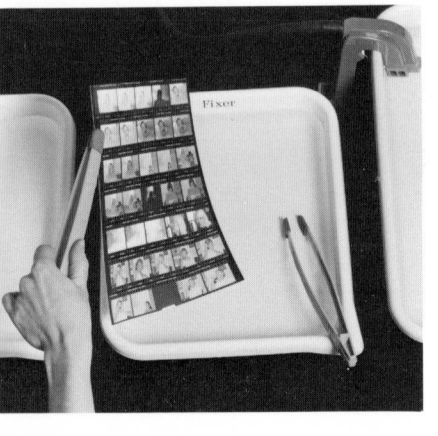
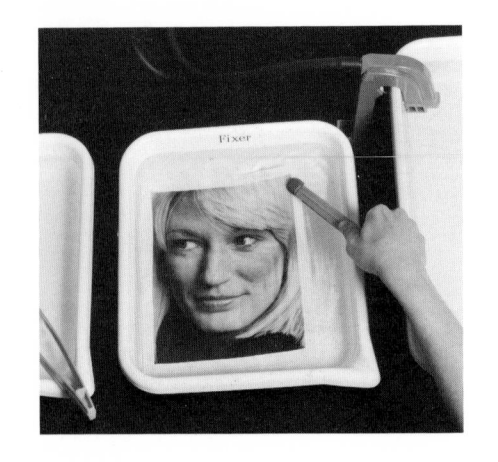

CHAPTER FIVE

Contents

Introduction

Millions of photographers, both amateurs and professionals, do their own darkroom work, and the number grows daily. The reasons behind this do-it-yourself approach are simple: the results you can achieve yourself are much better, more expressive, and less expensive than photographs that are processed and printed commercially.

This book is a complete guide to developing your negatives, making proof sheets and enlarged prints, and the techniques needed to get the best possible results from each of the processes. It is designed and laid out specifically to be taken into the darkroom with you where you will be working (other books must be read and memorized before proceeding). All of the background theory is separated from the step-by-step procedures to give you faster results. Many sections include "TIPS" from the professionals that will make your darkroom work more enjoyable and productive. The book features a special binding, which allows it to stand up or lie flat so that you can easily follow each step without losing your place.

A black background to the step-by-step photographs indicates steps that are performed in complete darkness or under safelight. A gray background indicates steps completed under normal room light.

All of the processes and times given in the book are for the recommended materials. Should you, for any reason, want to use other materials or experiment as you learn, just write in the revised processing times and temperatures in the step-by-step frames as described below.

The authors hope that they have simplified the presentation of processing and developing to the point where your first darkroom experience will be as successful and enjoyable as it should be.

Adjusting your processing times or temperatures

The step-by-step sequences in this book indicate times to set on your timer (or how long to time while watching the clock). Accompanying frames indicate the proper temperature for your chemicals. These are specific recommended times and temperatures for the materials and chemicals used in this book: Tri-X film, D-76 film developer (diluted 1:1), Kodak fixer, Dektol paper developer (diluted 2:1). Other materials may require different times or temperatures; write those numbers into the empty frame provided and use them as your guide when processing.

Unchanged

Changed

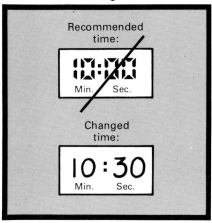

Unchanged

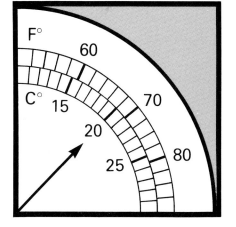

Changed

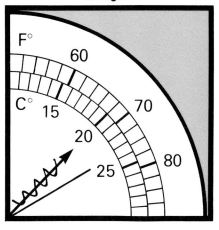

The time indicator The time given in the top part of the frame is the one suggested by the manufacturer of the materials used in this book. If your materials require a different time, write your own time into the lower part of the frame. These frames are found on pp. 23, 27, 29, 41, 45, 47, 59, and 61.

The temperature indicator The temperatures given on the dial are suitable for the materials recommended in this book. If you are using another temperature, you can enter the one you will be using (use a pencil so that you can erase and change it if needed at another time). Remember that any change in temperature will require a change in times, so double check the time frames also. These frames are found on pp. 23, 27, and 37.

CHAPTER ONE
Getting ready in 3 steps

Every year hundreds of thousands of new photographers are discovering the joy of developing their own film and making enlarged prints. With well over a million darkrooms in the United States alone, it's not difficult to imagine the almost endless variety of locations, sizes, and designs that photographers have come up with for their darkrooms. Like you, most photographers have to find a place for a darkroom that will not interfere with their everyday life. With enough ingenuity you, like other photographers, can put a darkroom almost anywhere. Many professionals, as well as most amateurs, work in darkrooms set up in bathrooms, closets, spare rooms, garages, basements, kitchens, or attics. Any space that can be lightproofed and has surfaces large enough to set up your enlarger and processing trays can work as a darkroom.

This chapter shows how to set up and organize a darkroom so that it works efficiently. Proven techniques on how to arrange working areas, how to lightproof the room, and how to mix your chemicals are discussed. After you have finished these first few steps, you'll be ready to develop film and make prints quickly and easily.

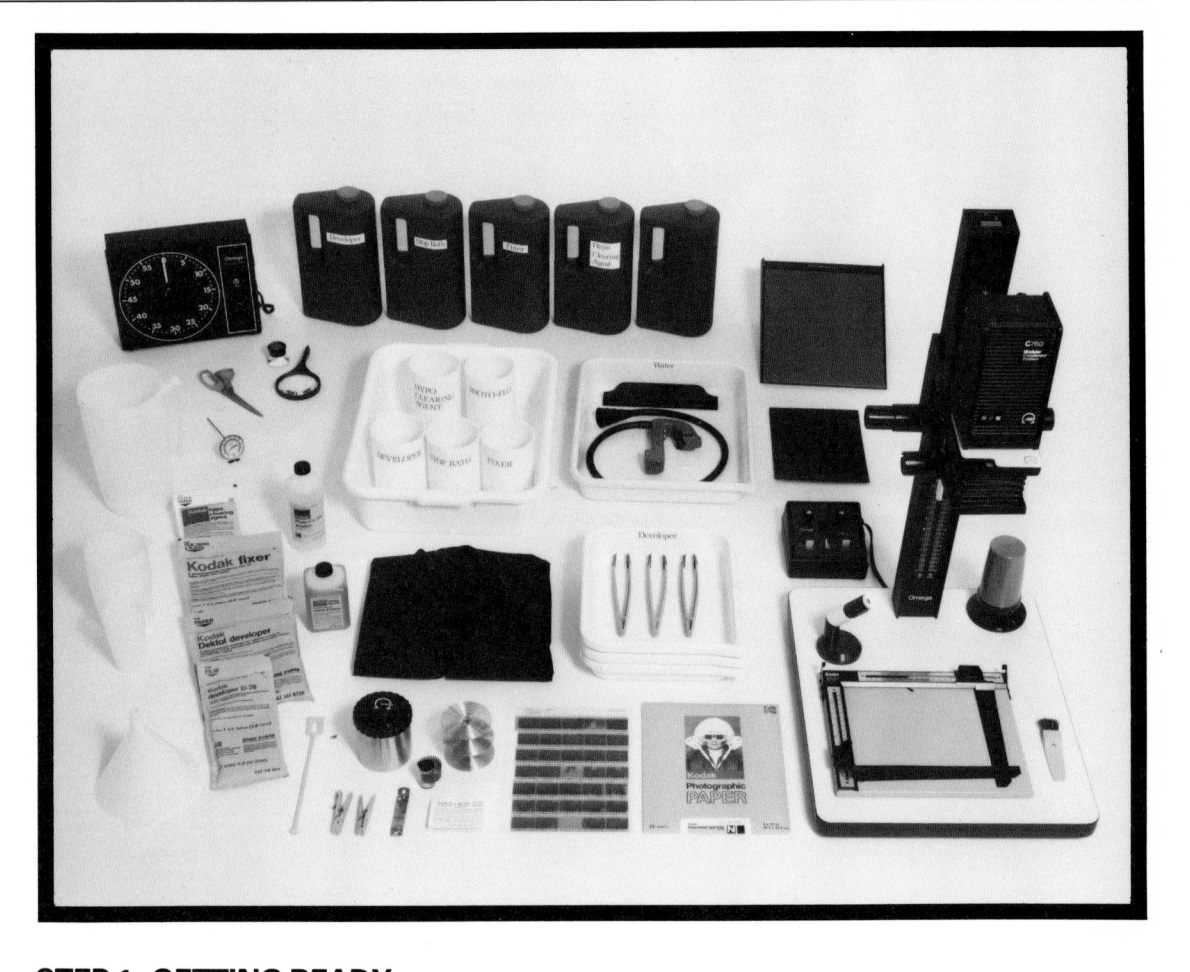

STEP 1: GETTING READY
Equipment you'll need

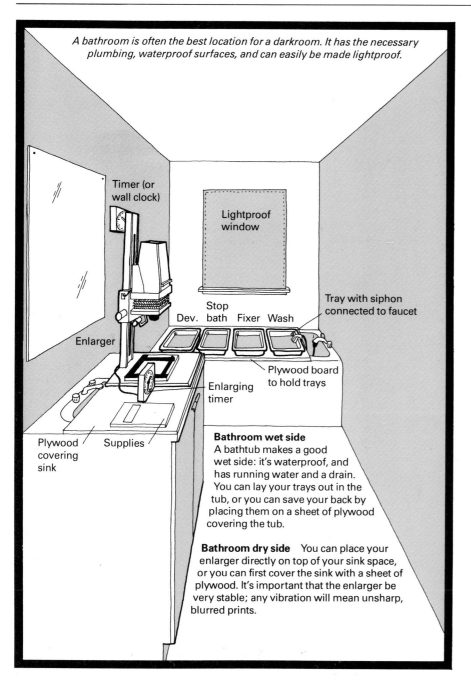

A bathroom is often the best location for a darkroom. It has the necessary plumbing, waterproof surfaces, and can easily be made lightproof.

Timer (or wall clock)

Lightproof window

Enlarger

Stop
Dev. bath Fixer Wash

Tray with siphon connected to faucet

Enlarging timer

Plywood board to hold trays

Plywood covering sink

Supplies

Bathroom wet side
A bathtub makes a good wet side: it's waterproof, and has running water and a drain. You can lay your trays out in the tub, or you can save your back by placing them on a sheet of plywood covering the tub.

Bathroom dry side You can place your enlarger directly on top of your sink space, or you can first cover the sink with a sheet of plywood. It's important that the enlarger be very stable; any vibration will mean unsharp, blurred prints.

STEP 2: SETTING UP YOUR DARKROOM
The basic approach
Ideas on where to put it
Keeping out the light

Equipment you'll need:	1 Adjust water temperature to:	2 Fill graduate with water to: (approx.)	3 Pour in chemical and stir until dissolved	4 Add water to bring level to: (exactly)	5 Pour into stock bottle and label
Film developer Kodak D-76 1 gallon (3785 milliliters) Gallon storage bottle Gallon mixing container (4 liters) Stirring paddle Thermometer Label	125° F 54° C	3½ qts. 3⅓ liters		1 gal. 3785 ml.	**D-76 (stock)** Film developer **To use:** Dilute 1 part D-76 with 1 part water. **Capacity:** 32 rolls of 36-exposure 35mm film when diluted 1:1. **Storage life:** 6 months in full container; 2 months in half-full container. **Date mixed:** / /
Paper developer Kodak Dektol 1 gallon (3785 milliliters) Gallon storage bottle Gallon mixing container Stirring paddle Thermometer Label	90–100° F 32–38° C	3½ qts. 3⅓ liters		1 gal. 3785 ml.	**Dektol (stock)** Paper developer **To use:** Dilute 1 part Dektol with 2 parts water. **Capacity:** 120 8 x 10 sheets when diluted 1:2. **Storage life:** 6 months in full container; 2 months in half-full container; 1 day in tray. **Date mixed:** / /

STEP 3: MIXING CHEMICALS
Equipment and tips you'll need
Preparing your stock solutions

STEP 1
Getting ready: Equipment you'll need

Processing film and making your own prints gives you much better results than commercial services do, and is also much less expensive. Getting set up, however, can be expensive if you buy only the best of everything you might want. To cut expenses, buy only what you really need, substitute common household items where possible, and buy used equipment, which is widely available.

This section describes the basic equipment you need. Common household items that can be substituted for special photographic equipment are indicated in parentheses.

General darkroom equipment

1 A timer with a range from 1 second to 60 minutes is needed to time the steps when processing negatives and prints. (a clock with a sweep second hand)

2 A photographic thermometer with a range of at least 50°–125°F (10°–50°C) is used when adjusting water and chemical temperatures during film and print processing.

3 Scissors, preferably with blunt tips, are needed to trim the film end before winding the film onto the developing reel and to cut paper for use as test strips.

4 A magnifying glass (or loupe) is helpful when examining the small images on your proof sheets to choose those you will enlarge.

5 A gallon mixing container is needed when mixing gallon quantities of chemicals. Ideally it should be marked in quarts and ounces or liters and milliliters on the side.

6 Graduates are needed to measure and dilute chemicals for use. The most useful sizes are: 32 oz (1 l), and 8 oz (250 ml).

Equipment for mixing chemicals

7 Chemicals needed include Kodak's D-76 Film Developer, Dektol Paper Developer, Fixer, Stop Bath, Hypo Clearing Agent, and Photo-Flo. (See pp. 12–15.) You can use other brands and types of chemicals, but these commonly available Kodak products are suggested for a start.

8 A funnel helps when pouring chemicals from trays or large mixing containers into storage bottles.

9 A stirring rod is used to mix chemicals with water. (stick or long-handled spoon)

10 Gallon storage bottles, with labels (minimum of five) are used to hold mixed chemicals until needed. Since light will affect the strength and shelf life of chemicals, opaque containers are best.

Equipment for processing negatives

11 A large pan can be used as a water bath to keep temperatures of mixed chemicals at the proper temperatures when processing negatives, and can also be used to wash prints in. (dish pan)

12 Holding containers (three to six) are used to hold chemicals when processing negatives. (old glass or plastic jars, 16 oz [500 ml] size)

13 A changing bag can be used to load film onto processing reels in a lighted room instead of loading film in a completely dark room.

14 A developing tank is designed to be loaded with reels in the dark, but once capped with its light-tight lid, all processing can be done in a normally lit room. The lid has a small cap, which can be removed so you can pour chemicals into and out of the tank without exposing the film to light. (See p. 18.)

15 Reels are used to separate the wound film in the developing tank so that the chemicals can flow freely over both sides of the film. (See p. 18.)

16 Practice roll of film can be used to practice loading a reel in daylight before loading the actual roll of film in the dark.

17 Film clips and a piece of wire on which to hang them are used to hang wet processed film to dry. (spring-loaded clothespins)

18 A cassette opener is needed to pry open the end of the 35mm film cassette. (bottle opener)

19 The film instruction sheet that comes packaged with your film contains important processing information. (See p. 20.)

20 Negative preservers to store processed negatives are available in a variety of formats, but the clear plastic type is the most convenient; proof sheets can be made without removing the negatives from the sheet. A permanent ink marking pen (like a "sharpie") is useful to label the preservers and prints without smearing. (See pp. 30 and 34.)

Equipment for making proof sheets and prints

21 Trays (a minimum of three) the size of the largest print you expect to make are needed for the developer, stop bath, and fixer solutions. To reduce the possibility of contamination, label each tray with black paint: "Developer," "Stop Bath," and "Fix."

22 Print tongs (three) are used to move the print from one processing tray to the next.

23 A print washer (tray with tray siphon) speeds up the washing of developed prints. (See p. 46.)

24 A print squeegee (or sponge) is used to remove excess water from washed prints to speed drying.

25 A proof printer, also called a contact printer or printing frame, is used to hold the negatives firmly against the paper when making proof sheets. (piece of glass with taped edges) (See p. 34.)

26 Black cardboard is used to block the light from the enlarger when making test strips for proof sheets and prints.

27 A timer (for enlarger) with a range from 1 second to 1 minute or more is needed to control the exposure times you will use when making prints and proof sheets.

28 An enlarger with the appropriate lens (50mm for 35mm negatives) projects light through the negative onto photographic paper to make enlarged prints. (See p. 38.)

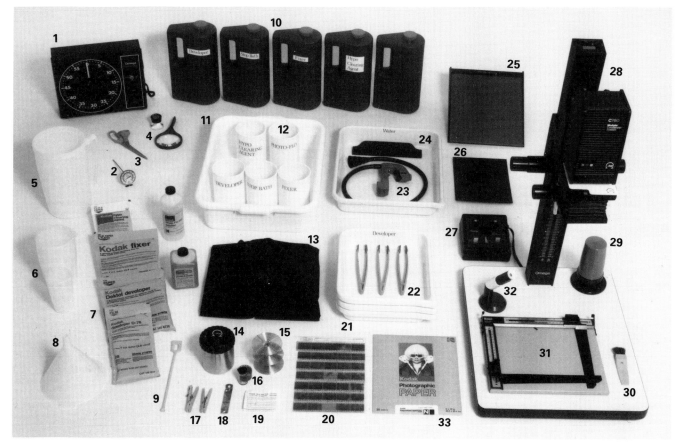

29 A safelight emits low-intensity, filtered light which allows you to see in the darkroom when making prints without exposing your photographic paper. (See p. 6.)

30 A brush, usually made from camel's hair, is used to remove dust from negatives and enlarging lens without causing scratches. An anti-static brush neutralizes any static electricity that attracts and holds dust on the negatives or lens. (See p. 54.)

31 An easel holds the printing paper flat, and those with movable blades can adjust the size of the image on your paper. (See p. 50.)

32 A grain magnifier is a device that is placed on the easel to allow accurate focusing. (See p. 50.)

33 Photographic paper is the light-sensitive material on which you print. A wide variety of sizes, surfaces, and tones governs the character of your prints. (See p. 34.)

Other equipment you might want

A drying screen
Paper towels and sponges
A slop pail
Rubber gloves
A grease pencil

Setting up your darkroom: The basic approach

When looking through your rooms for the ideal darkroom space, keep the following points in mind.

Convenience Kitchens and bathrooms are often needed for nondarkroom use. The inevitable interruptions may lessen your enthusiasm. A space that is free from interruptions may be more convenient.

Organization It is best to separate the dry side (where the enlarger is located) from the wet side (where chemicals are used).

Ventilation Some chemicals (stop bath in particular) have odors you may find irritating. Try to select a large room or one in which you can install a lightproof fan easily.

Lightproofing You should be able to lightproof the room with a minimum of bother. The fewer the windows and doors, the easier it will be. (See pp. 10–11.)

Running water Access to running water is essential, but it need not be in your darkroom space.

TIPS
Darkroom health and safety

Sharp edges Since you will be working in the dark or under the dim light of the safelight, hazards such as sharp counter corners or overhanging shelves should be padded or removed.

Contamination Some of the chemicals used to process film and paper can have harmful effects if used improperly. Wash your hands before eating, don't smoke or eat in the darkroom, store chemicals out of the reach of children, and don't re-use photographic equipment for other purposes.

Ventilation Fumes and dust from powdered chemicals can be harmful. Install a lightproof fan to improve circulation and always mix powdered chemicals in another room. If you are working in a small room without a fan, open the door occasionally to allow fresh air to circulate.

Electrical Electrical equipment such as your clock, safelight, or radio should be securely mounted or located where they could not accidentally fall into the sink or a tray filled with chemicals.

Allergies Some people develop skin rashes when they come in contact with some photographic solutions. If this happens to you, see your doctor. Wearing rubber gloves is one way to reduce your contact with chemicals.

Choosing a safelight

Safelights contain a bulb and a colored filter. As the light from the bulb passes through the filter, portions of it are blocked and only light of a certain color is allowed to pass: this light will not expose your enlarging paper (it will affect film, however). Although the light from a safelight is dim, it does allow you to see in the darkroom while making proof sheets and enlargements.

Two considerations when buying a safelight are where to put it and what kind of filter to use.

Where to put it Safelights can be screwed into existing ceiling or lamp fixtures, mounted on the wall, or placed directly on your counter. To reduce the chance of fogging (an overall graying of your paper), keep in mind that the safelight (with a 15w bulb) should be located at least 4 ft (1¼ m) from where your paper is exposed and processed. ▶

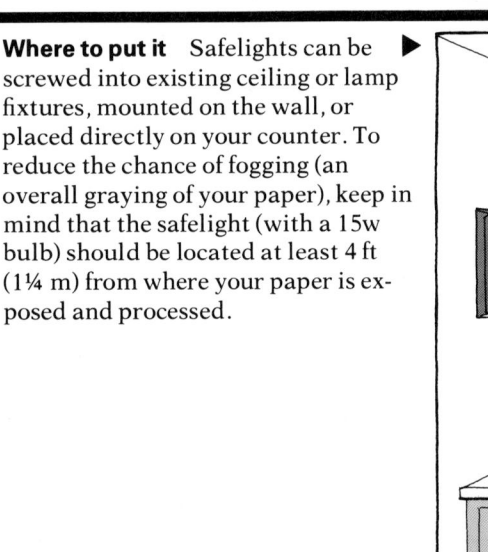

Ceiling unit

Wall unit

Counter unit

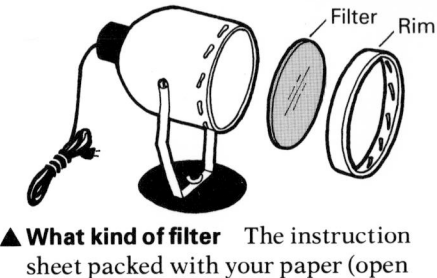

Filter Rim

▲ **What kind of filter** The instruction sheet packed with your paper (open the package only in the dark to remove it) specifies a particular type of filter. Most enlarging papers require a light amber filter such as a Kodak Wratten OC. Safelight filters are usually purchased separately from the safelight itself and come in a variety of shapes and sizes.

The dry side

Many materials used in the darkroom, such as film, developed negatives, enlarging paper, and contact sheets, can be harmed if they come in contact with processing solutions. The dry side of your darkroom, where negatives and unprocessed paper are used, should be separated by an aisle or splashboard (made from a piece of plywood) from the area where chemicals are used. When possible, all electrical equipment should be located on the dry side to prevent shock hazards.

The wet side

When processing negatives and prints in chemical solutions, there is always the possibility of spilling or splashing. For this reason a special area should be set up near the dry side, and preferably close to a source of water, where chemicals can be safely mixed and used. Most kitchen or bathroom counter surfaces are resistant to chemical staining, but if in doubt check with the manufacturer or cover the work surface with a plastic dropcloth.

Enlarger Place your enlarger towards one end of the dry side, preferably opposite or near the developer tray to reduce walking distances.

Enlarging timer The enlarging timer can be placed on the counter next to the enlarger or mounted on the wall to keep your work space open.

Electrical outlet You need access to an outlet for your enlarger, timer, and safelight. If one isn't nearby, you will need an extension cord.

Safelight A safelight for the dry side should be placed no closer than 4 ft (1¼m) to the enlarger.

Processing trays Trays for the developer, stop bath, and fixer are placed in the order in which they are used on the wet-side counter. Leave room between trays so that the chemicals can't slop from one tray into the next.

Print-viewing light A small print-viewing light can be mounted securely over the fixer or rinse tray so you can easily examine your prints.

Water tray or pan A fourth tray is needed next to the fixer to hold your prints in water prior to washing and to use as a print washer.

Developer

Stop bath

Fixer

Wash

Workspace Extra counter space, especially on the dry side, is helpful for laying out negative sheets, tools, and other items.

Sink Ideally, a sink should be available near the water tray to drain the water during washing. If you have no running water in your darkroom, the prints can be held in the fourth tray until they are washed in another room.

Timer A timer (or clock) with a sweep second hand is used for timing processing steps for negatives and prints.

**Setting up your darkroom
The basic approach**

STEP 2 (cont.)
Setting up your darkroom: Ideas on where to put it

Darkrooms can be placed in any type of home or apartment. Although you may need some ingenuity to solve individual problems, the ideas presented in this section have worked for many others in very similar situations. As you look around for possible locations, remember that the darkroom need not have running water, but it does need to be made lightproof.

Water connections

If you encounter problems with your water connections, solutions are usually as close as your nearest hardware or camera store. Here are some typical problems and solutions.

The washer won't connect to the faucet. Adapters are available that can connect your washer hose to either a threaded or unthreaded faucet outlet.

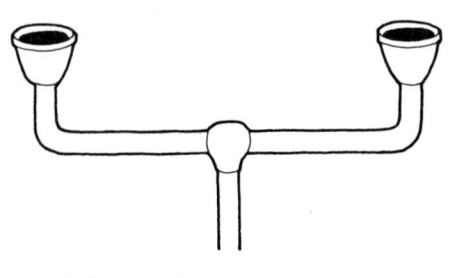

Your sink has separate faucets for hot and cold water. You can buy a water mixer that connects to both faucets and mixes the hot and cold water into one outlet.

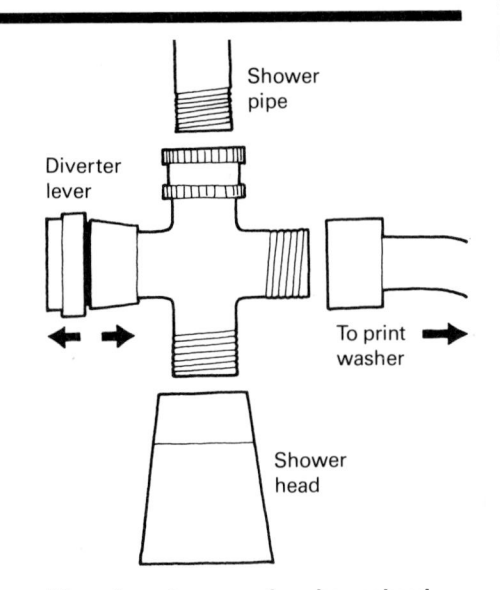

Shower pipe

Diverter lever

To print washer

Shower head

The only water source is a shower head. Shower diverters can be installed between the shower pipe and head. A movable lever diverts the water either to the shower head or for darkroom use.

You have only one faucet but need two outlets. A "Y" adapter can be screwed in place to give you an extra outlet.

A closet darkroom

A few innovations make even a small closet darkroom a feasible option. Wall-mount your timer and safelight or screw a safelight into the ceiling fixture. Use a tray rack to stack your three trays. Keep a bucket nearby for fixed prints that will be washed elsewhere. Construct a splashboard to protect your dry side. Store your chemicals below the counter. When set up, run an extension cord under the door to plug in your electrical equipment.

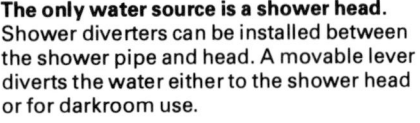

Safelight screwed into ceiling socket

Timer (or wall clock)

Enlarging timer mounted on wall

Enlarger

Splashboard

Print-viewing light

Developer

Tray ladder

Stop bath

Fixer

Shelf support

Storage shelves

Holding pan for processed prints

Comfortable working height (about 36″)

Slop bucket

Holding/rinse

A kitchen darkroom

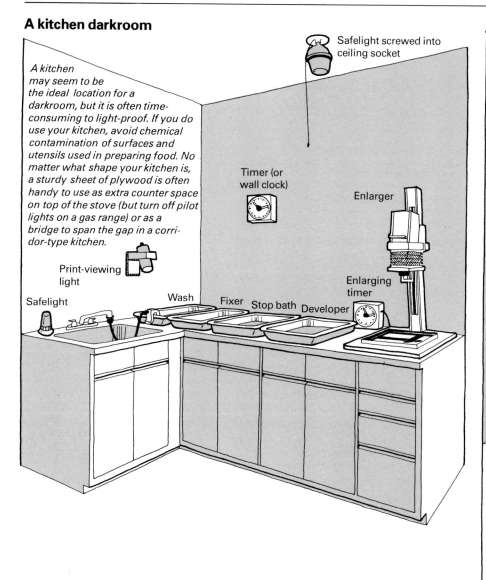

A kitchen may seem to be the ideal location for a darkroom, but it is often time-consuming to light-proof. If you do use your kitchen, avoid chemical contamination of surfaces and utensils used in preparing food. No matter what shape your kitchen is, a sturdy sheet of plywood is often handy to use as extra counter space on top of the stove (but turn off pilot lights on a gas range) or as a bridge to span the gap in a corridor-type kitchen.

Safelight screwed into ceiling socket

Timer (or wall clock)

Enlarger

Enlarging timer

Print-viewing light

Safelight

Wash

Fixer

Stop bath

Developer

A bathroom darkroom

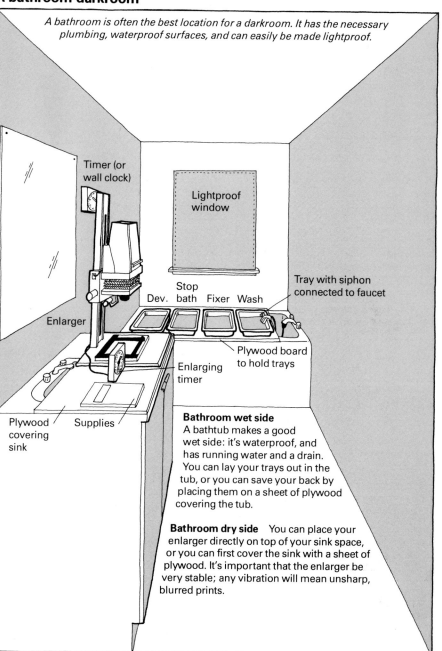

A bathroom is often the best location for a darkroom. It has the necessary plumbing, waterproof surfaces, and can easily be made lightproof.

Timer (or wall clock)

Lightproof window

Stop bath

Dev.

Fixer

Wash

Tray with siphon connected to faucet

Enlarger

Plywood board to hold trays

Enlarging timer

Plywood covering sink

Supplies

Bathroom wet side
A bathtub makes a good wet side: it's waterproof, and has running water and a drain. You can lay your trays out in the tub, or you can save your back by placing them on a sheet of plywood covering the tub.

Bathroom dry side You can place your enlarger directly on top of your sink space, or you can first cover the sink with a sheet of plywood. It's important that the enlarger be very stable; any vibration will mean unsharp, blurred prints.

Setting up your darkroom
Ideas on where to put it

STEP 2 (cont.)
Setting up your darkroom: Keeping out the light

If your darkroom isn't lightproof, it isn't a dark room. Small light leaks will fog your film and larger light leaks will fog your printing paper, that is, give either one unwanted overall exposure that results in a graying of the final print. Various sources of leaks are possible, depending on your darkroom's location. When checking for light leaks, give your eyes at least 5 minutes to adjust to the dark; you'd be surprised at how bright a kitchen stove pilot light becomes when your eyes finally adjust.

How to lightproof a door

A lightproofed door still has to open and close. You can lightproof the door, and still allow it to be usable, with inexpensive weather stripping and a rubber doorsweep available at any hardware store.

Materials needed

■ Weather stripping long enough to go around both sides and top of door (usually about 18 ft [5½ m]). Buy the widest available but at least 1 in wide.
■ Doorsweep long enough to cover bottom of door
■ Staple gun or tacks
■ Screwdriver or hammer
■ Hacksaw
■ Knife or scissors

Step by step

1 Measure bottom of door and cut doorsweep to length.
2 Screw or nail doorsweep in place so that rubber edge is in good contact with the floor (check it with the door closed, since floors can be uneven).
3 Cut a strip of weather stripping long enough to reach from the top to the bottom of the door. Staple or tack it in place so that enough stripping protrudes past the door's edge to cover the crack when the door is closed.
4 Cut stripping for top and hinge side of door and staple in place as above.

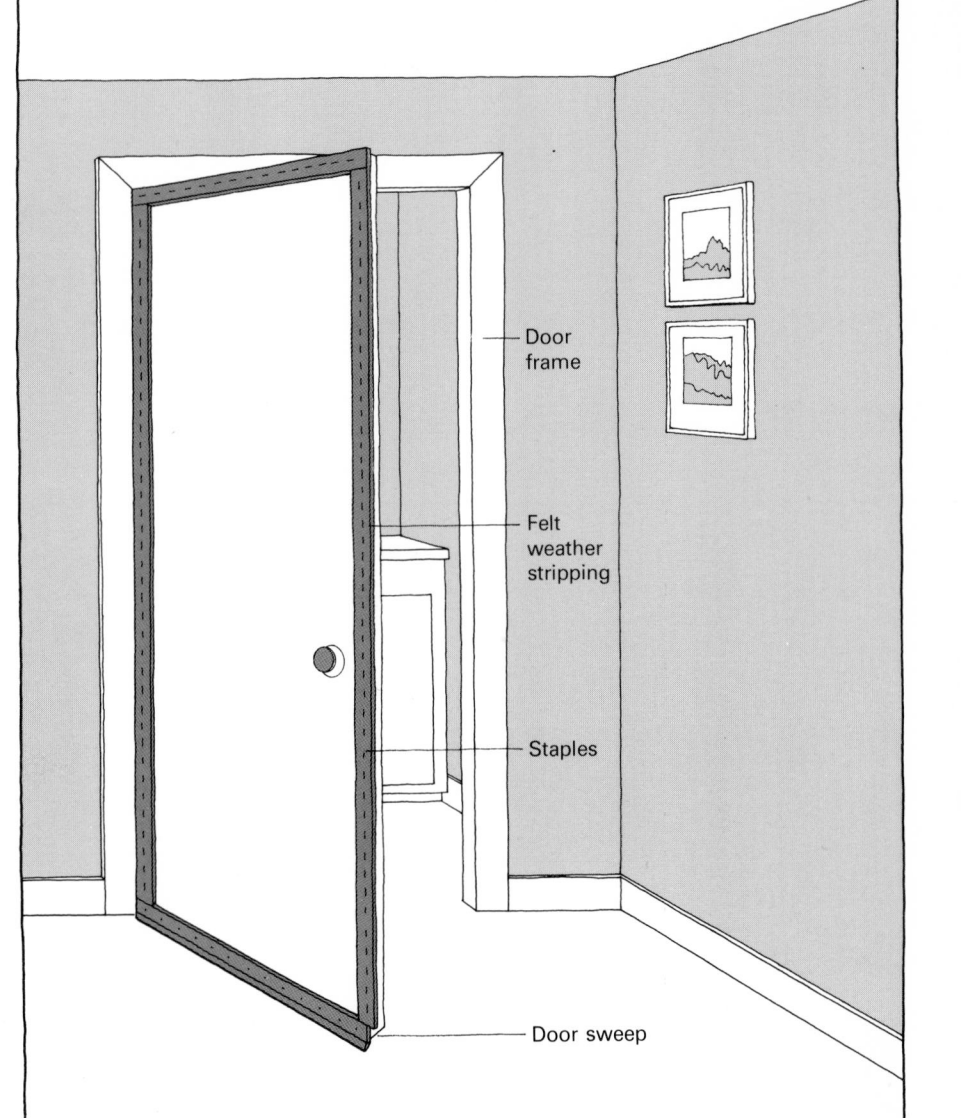

Door frame

Felt weather stripping

Staples

Door sweep

How to lightproof a window

The techniques used to lightproof a window range from painting it black (which is hard to remove the next day) to just lowering the shades and printing at night. A more flexible method is to cover the entire window with a sheet of masonite (or plywood) edged with felt weather stripping (or foam tape); your room is lightproofed, but you can easily remove the masonite whenever you want.

Materials needed
- Sheet of masonite (or plywood) large enough to cover the window and frame
- Felt weather stripping or foam tape long enough to run around entire edge of masonite panel
- A dozen or so short wood screws
- Tape measure
- Screwdriver
- Saw
- Glue
- Drill

Step by step
1 Measure the height and width of the outside of the window frame.
2 Lay out these measurements on the masonite panel and saw it to size. Check the panel against the window frame by holding it in place.
3 Drill a series of holes (large enough for screws to fit through the panel without catching) about every 18 in around edge of panel, ¼ in from edge.
4 Cut strips of the felt (or foam tape, which is self-adhesive) for each edge of the panel and glue them in place.
5 With someone holding the panel in place, screw a wood screw through each of the holes in the panel, and into the window frame.

If you eventually move or remove the darkroom, you can patch the holes in the window frame with wood putty, prime, and paint. If you need to improve your darkroom ventilation, you can insert a light-tight vent into the panel.

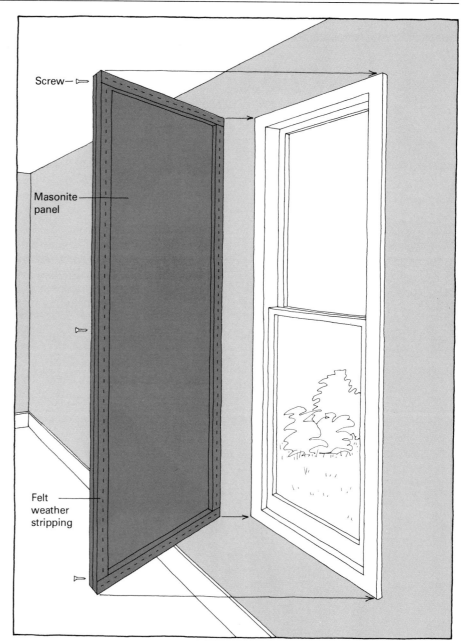

Screw

Masonite panel

Felt weather stripping

TIPS
How dark does it have to be?

When lightproofing doors and windows you will find that it is almost impossible to block every bit of light. You will frequently be able to see small cracks of light under doors, around panel edges, and through any cracks. As a rough guide for film loading, the room is dark enough if you cannot see objects in it after you have been in the room for 5 minutes with lights out. If you can see objects, or even see your hand in front of your face, use a changing bag to load film onto reels.

For printing, small cracks of light, unless they are right next to where you are enlarging or processing, often will not hurt your prints because printing paper is less sensitive to light than film is. If you have any doubts, either run a test to see if your paper is being fogged or print only at night when light leaks are minimal.

STEP 3
Mixing chemicals: Equipment and tips you'll need

Photographic chemicals are sold in either powder or liquid form. In this and the following section you will see how to mix these chemicals with water to give you either stock solutions (those that require further dilution prior to use) or working strength solutions (those that are ready to use without further dilution). When the initial mixing shown in this chapter gives you a "stock solution," instructions on how to dilute it are given at the point in the book when the dilution is required.

Always be sure to compare these instructions with the information that comes with your chemicals; instructions change occasionally and the package information may be more accurate.

Conversion tables

Quantities of photographic chemicals can be measured by U.S. liquid or metric measure, and their temperature measured in degrees Fahrenheit or degrees Celsius (Centigrade). These charts show the equivalent values required for converting photographic formulas from one system to the other.

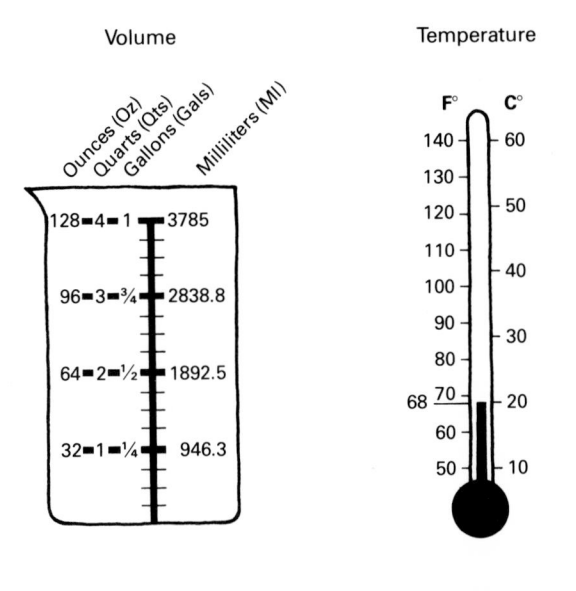

"Stock" vs. "working strength"

Photographic chemicals usually come as powders or liquids that have to be mixed with water prior to using them. After this initial mixing step, some chemicals are ready for use while others must be further diluted. Those that are ready for use without further dilution are called "working strength solutions" (stop bath, fixer). Those that require an additional dilution just prior to use are called "stock solutions" (Dektol, D-76). Dilutions are usually given as a ratio such as 1:1 or 1:2. The proportion of the chemical is given first, followed by the proportion of the diluting liquid. Dilute 1:2 means combine 1 part chemical with 2 parts water. This book gives step-by-step instructions for correct dilution. Once "stock solutions" are diluted for use, they become "working strength solutions."

"One-shot" vs. "replenishment"

The instructions packed with your film usually give different development times for D-76 depending on whether you use it undiluted or diluted with water 1:1. Most photographers prefer to dilute it (called "one-shot") since it can be discarded after use. If it is used undiluted, you can also discard it but it will develop only half as many rolls. You can return the undiluted developer to the storage bottle after using it, but you will have to keep an accurate record of the number of rolls processed and use a separate solution to "replenish" it. Without replenishment the undiluted developer will gradually lose strength and give you inconsistent results.

TIPS
Mixing chemicals

Avoid chemical contamination Mix your chemicals in the order of their use, i.e., developer, stop bath, fixer. Rinse all the utensils before mixing the next chemical and wash them with soapy water when you have finished.

Mix powdered chemicals in another room It is not healthy to breathe the dust from the dry chemicals, and they can damage your film and paper. Mix these chemicals in a large or well-ventilated room outside of the darkroom.

How long do you stir? Check the bottom of your mixing container after pouring the chemical solution into a storage bottle. If you see undissolved crystals on the bottom, pour the solution back and continue mixing until completely dissolved.

What does temperature have to do with mixing? Some chemicals dissolve best at a temperature that is higher than the normal tap water temperature. If, for instance, you mix D-76 at a temperature lower than 125°F (52°C), it takes much longer to dissolve all the powder that lies on the bottom of the graduate.

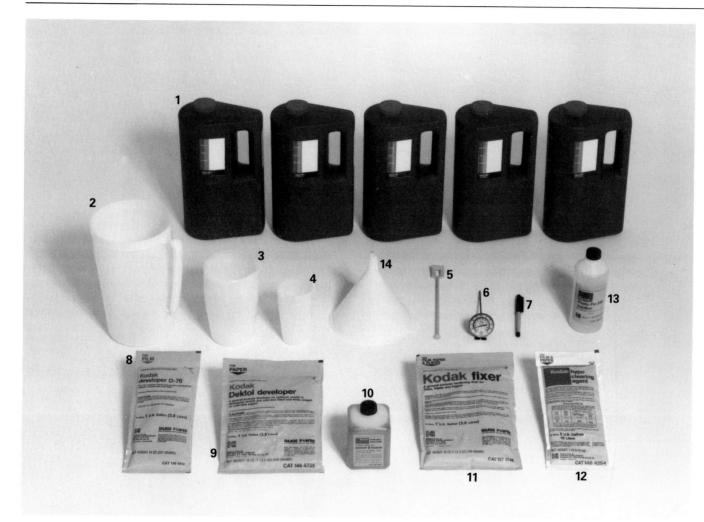

What each chemical does

D-76 is a film developer that produces negatives with normal contrast and fine grain. It gives the greatest sharpness when diluted 1:1 with water and is an excellent general-purpose developer for 35mm black-and-white film.

Dektol is a paper developer that produces neutral and cold-toned images on papers such as Kodak's Polycontrast Rapid II RC. It has a high capacity, uniform development rate, and good keeping qualities.

Stop bath stops the action of your developer when processing film and paper.

Fixer removes the excess silver crystals from the film and paper after development. It also usually contains a hardening agent, which helps to prevent the film and paper from being scratched after processing.

Hypo Clearing Agent promotes faster and more complete washing of films with less emulsion swelling or softening. It helps to remove the sulfer residue left from the fixer.

Photo-Flo minimizes streaks and drying marks on film. Its detergent-like composition decreases surface tension on the film so that excess water slides off easily. Instructions on diluting Photo-Flo are given on p. 30.

1 **Gallon storage bottles, with labels (five)**
2 **Gallon mixing container**
3 **32 oz (1 l) graduate**
4 **8 oz (250 ml) graduate**
5 **Stirring paddle**
6 **Thermometer**
7 **Waterproof marking pen (for labels)**
8 **Package of D-76 to make 1 gallon**
9 **Package of Dektol to make 1 gallon**
10 **Bottle of indicator stop bath, 16-oz**
11 **Package of fixer to make 1 gallon**
12 **Package of Hypo Clearing Agent, 5-gallon**
13 **Bottle of Photo-Flo**
14 **Funnel**

STEP 3 (cont.)
Mixing chemicals: Preparing your stock solutions

Equipment you'll need:	**1** Adjust water temperature to:	**2** Fill graduate with water to: (approx.)	**3** Pour in chemical and stir until dissolved	**4** Add water to bring level to: (exactly)	**5** Pour into stock bottle and label
Film developer Kodak D-76 1 gallon (3785 milliliters) Gallon storage bottle Gallon mixing container (4 liters) Stirring paddle Thermometer Label	125° F 54° C	3½ qts. 3⅓ liters		1 gal. 3785 ml.	**D-76 (stock)** **Film developer** **To use:** Dilute 1 part D-76 with 1 part water. **Capacity:** 32 rolls of 36-exposure 35mm film when diluted 1:1. **Storage life:** 6 months in full container; 2 months in half-full container. **Date mixed:** / /
Paper developer Kodak Dektol 1 gallon (3785 milliliters) Gallon storage bottle Gallon mixing container Stirring paddle Thermometer Label	90–100° F 32–38° C	3½ qts. 3⅓ liters		1 gal. 3785 ml.	**Dektol (stock)** **Paper developer** **To use:** Dilute 1 part Dektol with 2 parts water. **Capacity:** 120 8 x 10 sheets when diluted 1:2. **Storage life:** 6 months in full container; 2 months in half-full container; 1 day in tray. **Date mixed:** / /

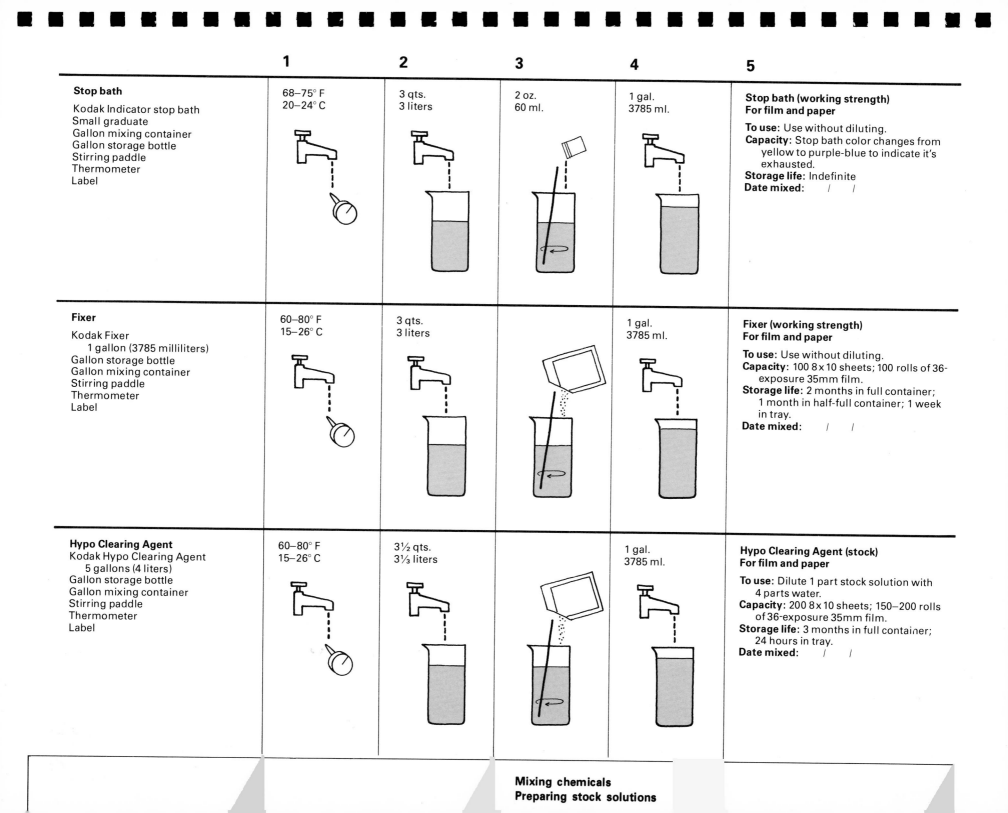

	1	2	3	4	5
Stop bath Kodak Indicator stop bath Small graduate Gallon mixing container Gallon storage bottle Stirring paddle Thermometer Label	68–75° F 20–24° C	3 qts. 3 liters	2 oz. 60 ml.	1 gal. 3785 ml.	**Stop bath (working strength)** **For film and paper** **To use:** Use without diluting. **Capacity:** Stop bath color changes from yellow to purple-blue to indicate it's exhausted. **Storage life:** Indefinite **Date mixed:** / /
Fixer Kodak Fixer 1 gallon (3785 milliliters) Gallon storage bottle Gallon mixing container Stirring paddle Thermometer Label	60–80° F 15–26° C	3 qts. 3 liters		1 gal. 3785 ml.	**Fixer (working strength)** **For film and paper** **To use:** Use without diluting. **Capacity:** 100 8 x 10 sheets; 100 rolls of 36-exposure 35mm film. **Storage life:** 2 months in full container; 1 month in half-full container; 1 week in tray. **Date mixed:** / /
Hypo Clearing Agent Kodak Hypo Clearing Agent 5 gallons (4 liters) Gallon storage bottle Gallon mixing container Stirring paddle Thermometer Label	60–80° F 15–26° C	3½ qts. 3⅓ liters		1 gal. 3785 ml.	**Hypo Clearing Agent (stock)** **For film and paper** **To use:** Dilute 1 part stock solution with 4 parts water. **Capacity:** 200 8 x 10 sheets; 150–200 rolls of 36-exposure 35mm film. **Storage life:** 3 months in full container; 24 hours in tray. **Date mixed:** / /

Mixing chemicals
Preparing stock solutions

CHAPTER TWO
Developing negatives in 3 steps

This chapter shows how to develop your exposed roll of film. The specific times and temperatures that are provided are based on your using Kodak Tri-X film, D-76 developer (diluted 1:1), and Kodak fixer. The basic procedure can be used for other film or chemicals; simply refer to the instruction sheet that was packed with your film (see p. 21 on how to read it) and enter the recommended times and temperatures for your materials in the time and temperature frames. Then use these times and temperatures rather than the printed ones.

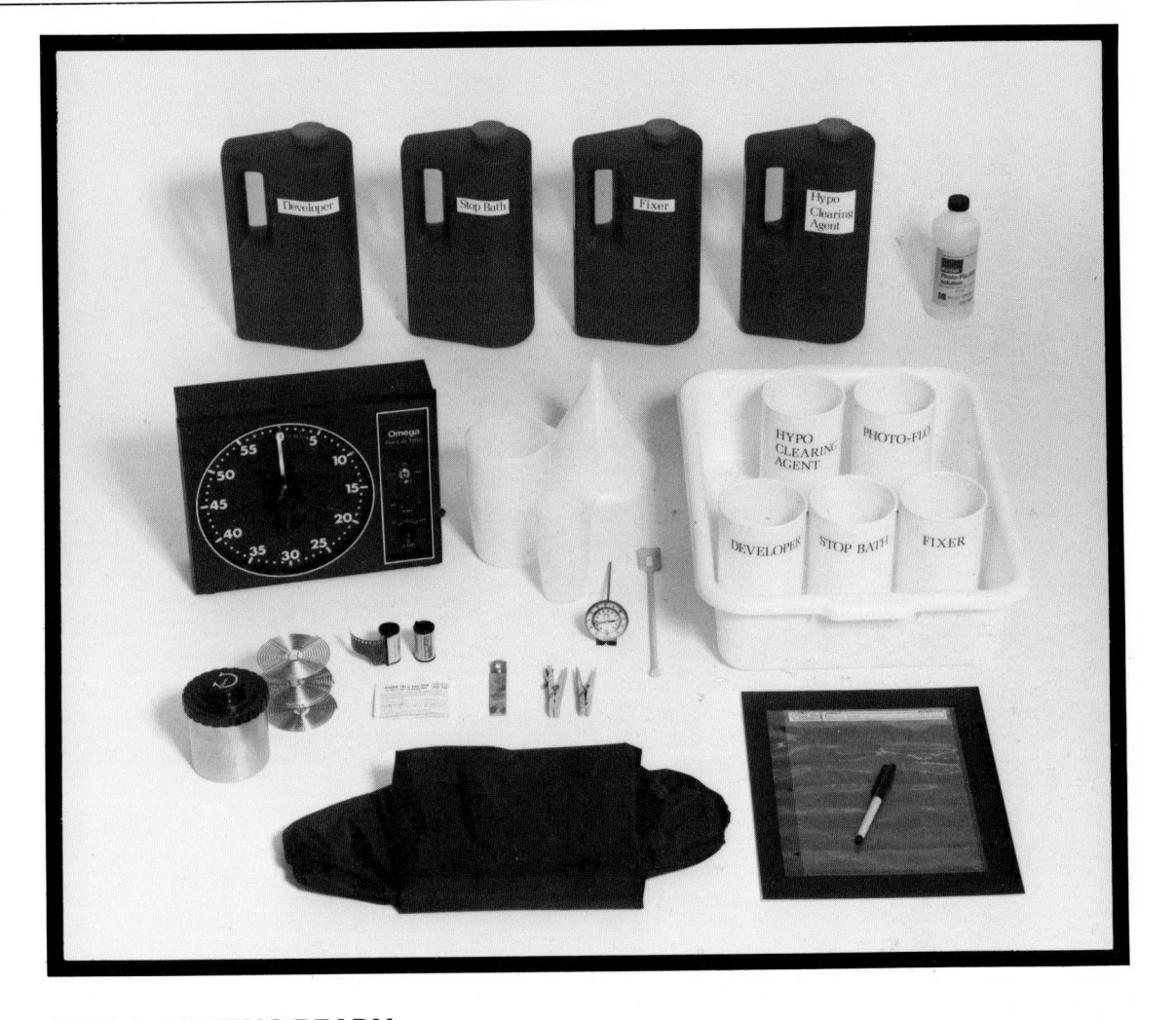

STEP 1: GETTING READY

Equipment you'll need
Using your film data sheet
Setting up the wet side

STEP 2: LOADING YOUR FILM ONTO REELS

2. Hold the reel With your other hand, feel for the outer end of the reel's spiral with the tip of your forefinger. Position the reel with the end of the spiral on top. Point the spiral in the same direction your forefinger is pointing.

rotate

4. Winding the film Hold the film slightly bowed and rotate the reel in the direction shown. Allow the film to be drawn through your fingers and onto the reel.

1. Holding the loose film Trim the end of the film square. Point the film towards the reel, with the film unwinding from the top. Bow the film by squeezing it lightly by the edges.

3. Attaching the film to the reel Guide the end of the film into the center of the reel. Make sure the film feeds in straight and sits squarely in the center. Attach the film to the clip or pin (if any) in the center.

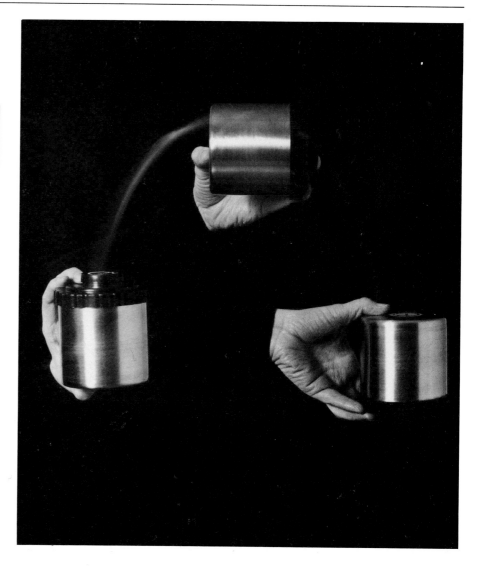

STEP 3: PROCESSING YOUR NEGATIVES
Developing
Fixing and rinsing
Washing and drying

STEP 1
Getting ready: Equipment you'll need

The equipment used to process your film is relatively simple and inexpensive. In total darkness (or inside a changing bag), the film cassette is opened with a cassette opener, the film end is trimmed and the film wound onto a reel. The reel is then placed into a lightproof developing tank. Once the film is in the tank and the tank cover is on tightly, the lights can be turned on and the film processed using the developer, stop bath, and fixer. Once fixed, the film can be removed from the tank, washed and dried.

Automatic film loaders

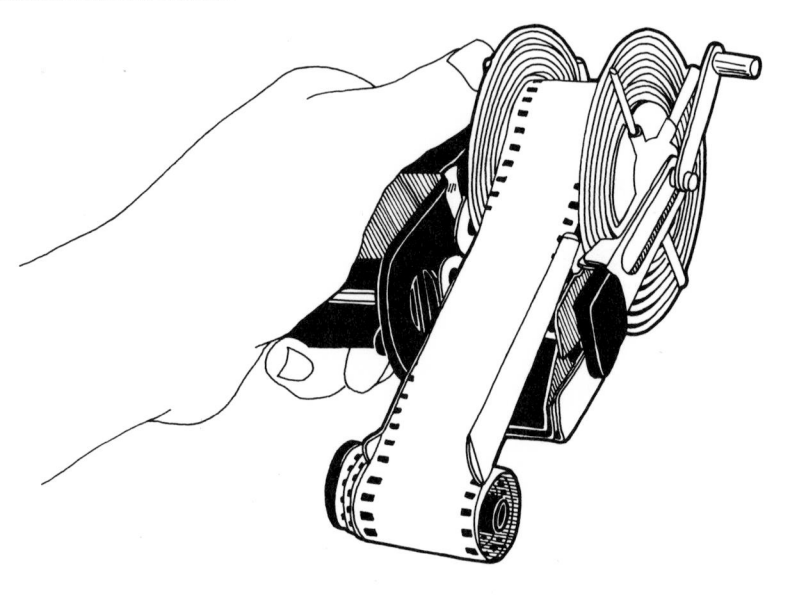

Loading film onto the developing reel is quite easy once you get the hang of it. But if you have persistent trouble loading your reels by hand, you may wish to experiment with an automatic film loader. These devices come in a variety of models, from mechanical winders to simple plastic guides. One model has a post which slides through the center of the reel like an axle. Film is then inserted through a guide and fastened to the clip in the middle of the reel. As you crank the winder, the guide automatically bows the film and feeds it into the reel straight.

Choosing your tank and reel

Buy the best tanks and reels you can afford; poor quality tanks and reels may eventually rust or leak and good ones will last a lifetime.

Tanks and lids Developing tanks and lids are available in both plastic and stainless steel models; some have stainless steel bodies with plastic lids. Plastic lids create a tighter seal than stainless steel lids, which can leak during agitation and are subject to misalignment if dropped and bent out of shape. Tanks are available in capacities ranging from 1- to 14-reel sizes. The best size for you depends on how many rolls you will normally want to develop at a time. A 2-reel tank is a good buy regardless of how many rolls you usually process; even the most avid photographers find they often develop just 1 or 2 rolls at a time.

Reels Reels hold the wound film apart so that processing chemicals can circulate around both sides of the film. There are plastic reels which adjust for different widths of film, but many photographers prefer nonadjustable stainless steel reels for their proven durability. Reels for 35mm film are available in sizes to hold 20- or 36-exposure rolls. Because of its wider grooves, the 20-exposure reel is easier to load, but the 36-exposure reel is more versatile because it can be used for either length of film.

The dry side

1. Your exposed roll of Tri-X 35mm film
2. A practice roll of film
3. A cassette opener
4. The developing tank, lid, and reel
5. A changing bag (or lightproof room)
6. A negative preserver sheet and marking pen
7. Film data sheet

The wet side

8. Chemicals
 D-76 (stock solution)
 Stop bath (working strength)
 Fixer (working strength)
 Hypo Clearing Agent (stock solution)
 Photo-Flo (stock solution)
9. A thermometer
10. Two graduates (32 oz and 8 oz)
11. A stirring rod
12. A large pan
13. A timer (or clock with sweep second hand)
14. Film clips (or spring clothespins) and wire
15. Five holding containers
16. Funnel

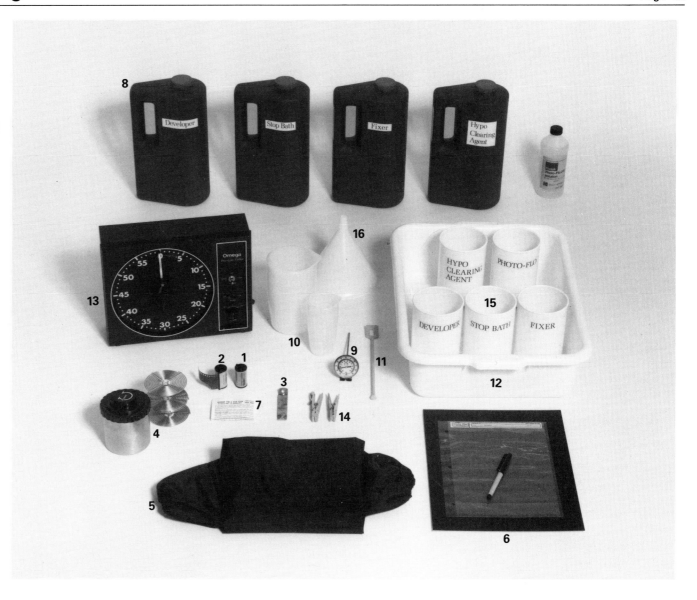

Getting ready: Using your film data sheet

Film manufacturers include a sheet of instructions with each roll of film. These instructions are a very short course in photography and give both exposure and processing information. Since processing procedures and times occasionally change, you should always refer to this instruction sheet even after you gain more experience.

When would you adjust processing times?

Different types of film require different processing times.

Different types of developers usually require different processing times.

Presoaking your film in water prior to development improves the evenness of your development (presoak in 68°F [20°C] water for 30 seconds). It also reduces the possibility that air bubbles will cling to the surface of your film, causing airbells (see p. 86). If you use a presoak, you should extend the recommended development time by 10% (for instance, from 10 minutes to 11) and note the changed time in the time frames.

A large tank that cannot be inverted for agitation will require a time change, for example, an 8-reel tank that is agitated by lifting all the reels on a central spindle. If you have a tank that cannot be inverted, look on your film instruction sheet for large-tank processing.

Different processing temperatures require different processing times. If your developer temperature is colder than the recommended 68°F (20°C), the developing time will be longer since chemical reactions are slower at colder temperatures. Likewise, if the processing temperature is warmer than 68°F (20°C), the developing time will be shorter since chemical reactions are faster at warmer temperatures.

Film or chemical manufacturing changes occasionally alter the suggested processing time. Double check the instruction sheet that was packed with your film to make sure no changes have been made. Manufacturers use these sheets to alert you to any changes that would affect development.

Consistently over- or underdeveloped film (see pp. 26 and 82–87) can be eliminated by changing your processing time. All developing times provided by manufacturers are just suggestions and may be inaccurate for your situation. Your water quality, dilution habits, and other variables also can affect your results.

Adjusting your processing times or temperatures

The step-by-step sequences in this book indicate times to set on your timer (or how long to time while watching the clock). Accompanying frames indicate the proper temperature for your chemicals. These are specific recommended times and temperatures for the materials and chemicals used in this book: Tri-X film, D-76 film developer (diluted 1:1), Kodak fixer, Dektol paper developer (diluted 2:1). Other materials may require different times or temperatures; write those numbers into the empty frame provided and use them as your guide when processing.

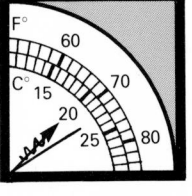

The temperature indicator The temperatures given on the dial are suitable for the materials recommended in this book. If you are using another temperature (see box at left for reasons why), you can enter the one you will be using (use a pencil so that you can erase and change it if needed at another time). Remember that any change in temperature will require a change in times, so double check the time frames also.

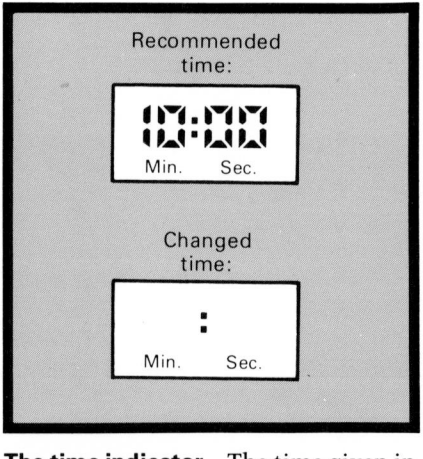
Unchanged

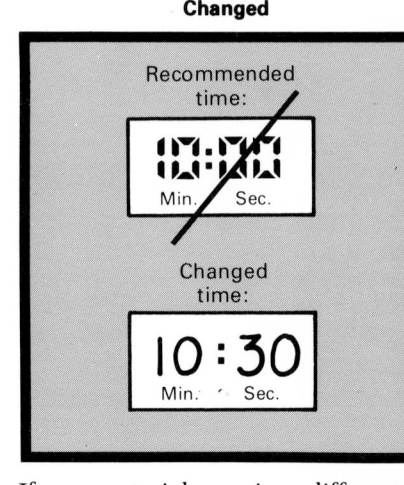
Changed

The time indicator The time given in the top part of the frame is the one suggested by the manufacturer of the materials used in this book.

If your materials require a different time, write your own time into the lower part of the frame.

Handling Handle the film in total darkness. Although the film can be inspected during development, many photographers find it hard to evaluate the small 35mm negatives correctly without fogging the film in the process.

Developing The development times are suggestions based on general use under "normal" conditions. Your own processing times may differ.

Choosing a developer D-76 (diluted 1:1) is used in this book because it is a widely available and popular general-use developer. You might prefer, for some reason, to use another type or brand of developer. Your local photo dealer can show you other developers.

Choosing a temperature Although 68°F (20°C) is the recommended processing temperature, you may need to adjust it if your incoming water is warmer or colder.

Finding the development time You can determine the suggested development time by following the numbers across the chart from your specific developer to the column under your chosen processing temperature.

REVISED 4-79

KODAK TRI-X PAN FILM

Recommended Development for Short Lengths (up to 5-Foot Lengths):

KODAK Packaged Developers	Developing Times (in Minutes)*									
	SMALL TANK†—(Agitation at 30-Second Intervals)					LARGE TANK†—(Agitation at 1-Minute Intervals)				
	65°F 18.5°C	68°F 20°C	70°F 21°C	72°F 22°C	75°F 24°C	65°F 18.5°C	68°F 20°C	70°F 21°C	72°F 22°C	75°F 24°C
HC-110 (Dilution B)	8½	7½	6½	6	5	9½	8½	8	7½	6½
POLYDOL	8	7	6½	6	5	9	8	7½	7	6
D-76	9	8	7½	6½	5½	10	9	8	7	6
D-76 (1:1)	11	10	9½	9	8	13	12	11	10	9
MICRODOL-X	11	10	9½	9	8	13	12	11	10	9
MICRODOL-X (1:3)	—	—	15	14	13	—	—	17	16	15
DK-50 (1:1)	7	6	5½	5	4½	7½	6½	6	5½	5
HC-110 (Dilution A)	4¼	3¾	3¼	3	2½	4¾	4¼	4	3¾	3¼

*With properly exposed film, these suggested developing times should yield negative contrast suitable for printing with a diffusion enlarger or by contact. For printing with a condenser enlarger, a lower contrast (achieved by a reduction in development time) is usually desirable. For complete information about contrast control, see Kodak Publication No. F-5, *KODAK Professional Black-and-White Films*.
†Unsatisfactory uniformity may result with development times of less than 5 minutes.
Note: Do not use developers containing silver halide solvents.

Rinse at 65 to 75°F (18.5 to 24°C) with agitation.
KODAK Indicator Stop Bath—30 seconds
or KODAK Stop Bath SB-5 —30 seconds
Fix at 65 to 75°F (18.5 to 24°C) with agitation.
KODAK Fixer —5 to 10 minutes
or KODAK Fixing Bath F-5—5 to 10 minutes
or KODAFIX Solution —5 to 10 minutes
or KODAK Rapid Fixer —2 to 4 minutes
Wash for 20 to 30 minutes in running water at 65 to 75°F (18.5 to 24°C). To minimize drying marks, treat in KODAK PHOTO-FLO Solution after washing, or wipe surfaces carefully with a KODAK Photo Chamois or a soft viscose sponge. To save time and conserve water, use KODAK Hypo Clearing Agent.
Dry film in a dust-free place. Long rolls of film can be air-dried without removing them from their processing reels.

© Eastman Kodak Company, 1979

Size of tank The size of the tank affects development. Agitation is less frequent in large tanks (5 or more reels); therefore, the development times are longer than for small invertible tanks.

Rinse You can rinse your film in a stop bath rinse as indicated, or you can use a running water rinse instead. (See p. 22.)

Fix Fixer removes undeveloped silver from the film, and different types fix at different rates. Follow the manufacturer's recommendations since under- or overfixing your film can cause problems. (See p. 28.)

Wash Washing your film after fixing removes chemical residue that can harm your film. A clearing agent rinse shortens the necessary wash time and helps to conserve water.

Dry Dry the film in a dust-free environment for a few hours to prevent dust particles from drying into the emulsion (dust shows up as white spots on your prints).

Getting ready: Setting up the wet side

Once you have selected your development time and temperature, you can get ready to develop your film. Some of the stock solutions prepared previously now need to be diluted to working strength. Follow the dilution tables on this and the following pages as you process.

After diluting the chemicals pour them into smaller, easier-to-handle holding containers and place the containers in a pan of water (called a *water bath*) set at the correct temperature (see opposite). While the chemical temperature adjusts, you can load your film onto reels as shown on pp. 24–25.

> **TIPS**
> **How to adjust temperatures**
>
> It is important that each chemical used in processing your film be kept very close to the chosen processing temperature. Put all the chemicals (each in its own container) into a pan partially filled with water (called a water bath) at the temperature you have chosen. The water temperature will change as it warms or cools the chemicals, so use your thermometer to check and adjust it periodically.
>
> When the chemicals' temperature matches that of the water bath, and they are all at the correct processing temperature, the chemicals are then ready to be used.
>
> **If the water bath is too cold** Slowly add hot water to the pan and stir it as you monitor the temperature. Make sure that the hot water does not splash into the open containers; this would change their strength.
>
> **If the water bath is too hot** Slowly add cold water or ice cubes to the water bath and stir it as you monitor the temperature. Again, make sure you don't accidentally change the chemical dilution.

Stop bath or rinse?

Stop bath is a mild solution of acetic acid, used to stop the development of your film quickly and evenly. The stop bath neutralizes the developer alkalies left in the film, and prolongs the life of the fixer as well. Some photographers claim that stop bath can harm film and prefer to use a water rinse instead. After a 10-minute development, any additional development that may take place while the film is in the rinse is minimal. Once you have gained experience you may decide in favor of a short rinse in 68°F (20°C) water, but when first starting a stop bath will reduce the possibility of mistakes.

Diluting your "stock" D-76			1	2	3	4	5
If you want:	Dilution needed:	Start with:	Adjust water temperature to:	Fill graduate with water to:	Fill graduate with stock D-76 to bring level to:	Stir until well mixed	Pour into holding container (see step 2 below)
D-76 (working strength)	1:1	D-76 (stock)	68° F 20° C	8 oz. 250 ml.	16 oz. 500 ml.		
16 oz./500 ml. (enough for 2 rolls)		see p. 14 on how to mix stock solution					

1 EQUIPMENT NEEDED

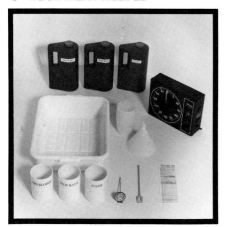

D-76 developer, stop bath, fixer, graduate, funnel, holding containers (three), a large pan, thermometer, stirring paddle, film data sheet, timer.

2 DILUTE DEVELOPER

Dilute your D-76 stock solution as shown above and pour into one of the holding containers.

3 STOP BATH

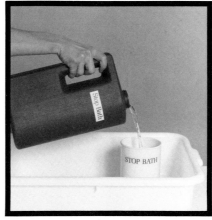

Pour about 16 oz (500 ml) of stop bath from its storage bottle into one of the holding containers.

4 FIXER

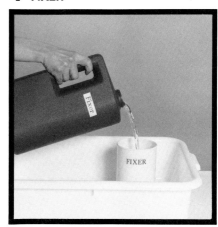

Pour 16 oz (500 ml) of fixer from its storage bottle into one of the holding containers.

5 PREPARE WATER BATH

Place all holding containers into one large pan in the order they will be used (developer, stop bath, fixer). Partially fill pan with water at approximately 68°F (20°C).

6 ADJUST WATER BATH

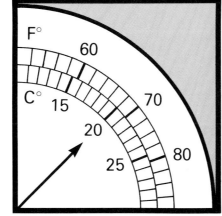

Adjust water bath temperature, using the techniques shown above to bring it to 68°F (20°C). The temperature will change as it warms or cools the chemicals, so check periodically.

7 SELECT DEVELOPMENT TIME

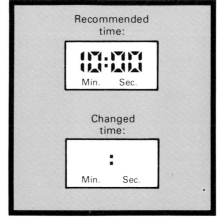

Check time in frame above against your film data sheet. If it's not the same (or if you use a presoak) change time in this frame and frame 18 on p. 27.

8 WASH AND DRY HANDS

It usually takes awhile for the water bath to adjust the chemical temperatures. At this point you can load your reels as shown on next page.

Getting ready
Setting up the wet side

The hardest part about winding your reels is having to do it in complete darkness. Practice getting the feel of loading your reel by winding the film from an unexposed practice roll in the light. Watch what happens so you can mentally picture the actual loading job later on in the dark. Then try winding the same practice film onto the reel with your eyes closed or with the lights off. After several practice runs, you should be able to load the exposed roll of film in the dark without trouble.

If you are not absolutely certain that your darkroom is lightproof enough to load film safely you should use a changing bag.

What's inside the film cassette

When you remove the end of the cassette (#1) on your practice roll of film, you will find the film (#2) tightly wound around a spool (#3) inside the cassette (#4). As you push the spool out, the film will try to unwind like the mainspring in a watch. Keep the film wound by holding it loosely by the edges; avoid getting fingerprints or scratches on it. The film will naturally loosen up a bit on its spindle, but if the film completely unwinds (for example, if you drop it) carefully rewind it back onto its spool before attempting to load your reel.

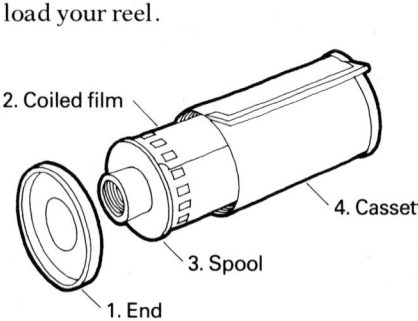

2. Coiled film
4. Cassette
3. Spool
1. End

Where to trim the film

Trim the end of your film before loading it onto the reel. This must be done in complete darkness, so try this first on your practice roll. Feel for the end of the film, and then follow the curve of the film lead with your finger. Trim the film just inside the curve as shown. If the film end crimps or tears as you try to load it on the reel, you may need to retrim the end to gain a fresh start.

Cut here

Starting the film winding

Always handle your film by the edges with dry hands to avoid getting fingerprints on its surface.

2. Hold the reel With your other hand, feel for the outer end of the reel's spiral with the tip of your forefinger. Position the reel with the end of the spiral on top. Point the spiral in the same direction your forefinger is pointing.

rotate

1. Holding the loose film Trim the end of the film square. Point the film towards the reel, with the film unwinding from the top. Bow the film by squeezing it lightly by the edges.

3. Attaching the film to the reel Guide the end of the film into the center of the reel. Make sure the film feeds in straight and sits squarely in the center. Attach the film to the clip or pin (if any) in the center.

4. Winding the film Hold the film slightly bowed and rotate the reel in the direction shown. Allow the film to be drawn through your fingers and onto the reel.

TIPS
Is the film winding correctly?

Check for slack After every few revolutions of the reel, gently slide the film back and forth to see if you can feel about ⅜ in (1 cm) of movement in and out. If not, the film has probably jumped a track and needs to be unwound until you can feel slack, and then rewound.

Feel along the edges As you wind the film, occasionally run your fingers along both sides of the reel to make sure no film is protruding. Your film may push out through the spirals if it has kinked. If you can feel some film sticking out along the edges, unwind the film until you go past the kink, then rewind.

Feel for the end of the film Use your practice roll to determine where the film ends when wound on the reel. A properly wound 36-exposure roll of film wound on to a 36-exposure reel ends close to the end of the reel. A 20-exposure roll of film will end sooner. If you have too much or too little film left, the film may have come out of the reel's clip and slipped several grooves before it caught, or there might be a section where the film overlaps. If so, unwind the film and start over.

Step by step

9 EQUIPMENT NEEDED

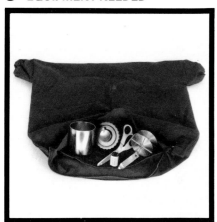

Place film, cassette opener, scissors, developing tank, reel and lid in a changing bag (or use lightproof room), zip both zippers shut, and insert your hands into sleeves of bag.

10 OPEN CASSETTE

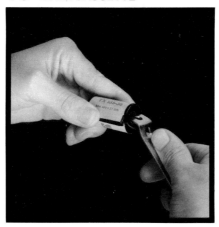

Open the flat end with a cassette opener and push out the film.

11 TRIM END

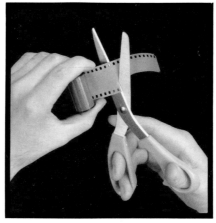

Cut off the film leader so that the end is square.

12 ATTACH TO REEL

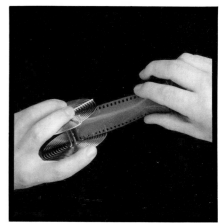

Hold reel in your left hand so the spirals go in the direction your forefinger is pointing. Bow the film slightly and insert into clip in center of reel. (See above for more details.)

13 REVOLVE A FEW TIMES

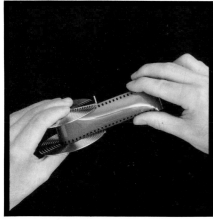

Carefully revolve the reel a few times while you keep the film bowed. If the film kinks, start over.

14 TEST

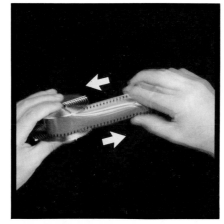

Keep the film bowed as you continue to wind the film. Use one of the loading tests (see above) to be sure the film is winding correctly.

15 CONTINUE WINDING

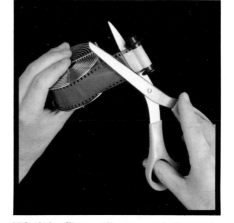

Wind the film until you reach the end that is taped to the spool. Cut the film free. Don't tear the film or a static spark may flare the film. Double check for kinks.

16 LOAD IN TANK

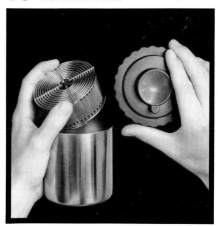

Put loaded reel in tank and securely fasten lid. When developing 1 roll in a 2-or-more-roll tank, place an extra reel or reels on top to prevent excess agitation.

Loading your film onto reels

Processing your negatives: Developing

Once your film is wound onto reels and inserted into the lightproof tank, the room lights can be turned on and all processing steps completed in normal room light. Chemicals can be poured into (and out of) the tank by removing the small cap (not the entire lid) and tilting the tank to allow the air to escape as the chemicals enter.

The steps on each of the following pages are laid out so you don't have to turn the page during a critical step.

The entire process should be completed in a continuous uninterrupted sequence but the only really critical steps are getting the developer into and out of the tank at the right times and rinsing the film immediately to stop development.

Agitation

Periodic agitation is necessary to ensure even development of the entire film surface. The processing chemicals that are in contact with the surface of your film become exhausted after a short time; agitation brings fresh chemicals in contact.

Rap tank Immediately after filling your tank with developer and recapping it, strike it sharply against the counter or floor to dislodge air bubbles clinging to the film surface. If not removed, these bubbles will prevent developer from reaching your film in that spot. These undeveloped areas will appear as dark spots on your prints.

Agitate completely Invert your tank ► gently once or twice (this should take about 5 seconds). Do this once every 30 seconds during development.

What's happening inside the tank?

Developer has the most noticeable effect of any of the processing chemicals on your film: it makes the picture appear. The image doesn't appear all of a sudden; it is a gradual process. The image will first appear in the most heavily exposed parts of the negative (highlights) and last in the least exposed areas of the negative (shadows).

Underdevelopment

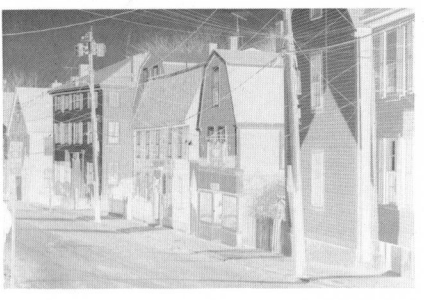

Negative developed for 4½ minutes: Activity is slow during the first part of processing as the developer soaks into the emulsion. Each area on the film darkens in proportion to the light it received during the exposure: here, the highlights are darkening, the midtones are appearing, and the shadow detail cannot yet be seen.

Normal development

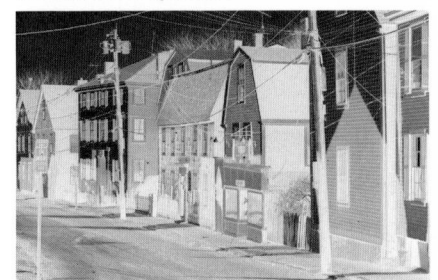

Negative developed for 10 minutes: This normally developed negative shows good detail in the highlights, the midtones, and the shadows. If you were to place a properly exposed and developed negative against the type on this page, you should be able to barely read the words through even the darker areas.

Overdevelopment

Negative developed for 20 minutes: In this overdeveloped negative, the highlights have blocked up (gotten so dark that no detail is visible), the midtones have darkened although you can still see detail, and the shadow detail has barely changed. You would not be able to read type through these highlights since their density has approached its maximum.

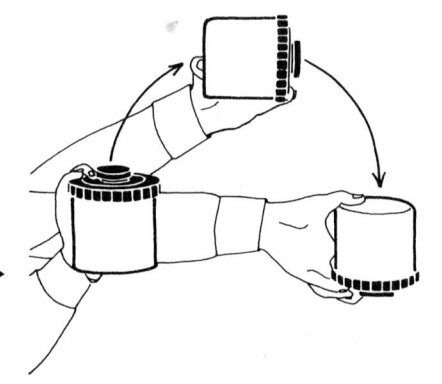
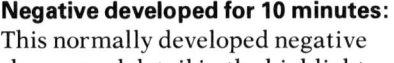

Step by step

17 CHECK TEMPERATURES

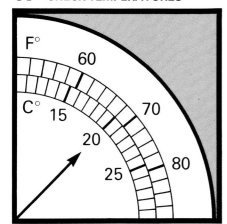

Your developer should be exactly 68°F (20°C) and the stop bath and fixer within a few degrees of the developer. If they are not, continue to adjust temperatures or select a new time.

18 SET TIMER

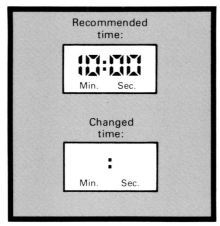

Recommended time:

10:00
Min. Sec.

Changed time:

:
Min. Sec.

Set the time indicated above on your timer.

19 START DEVELOPMENT

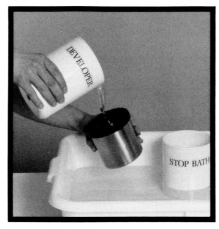

Remove the small cap from tank lid, tilt tank, start timer, and pour in developer to just below top of tank. Recap the tank.

20 RAP AND AGITATE TANK

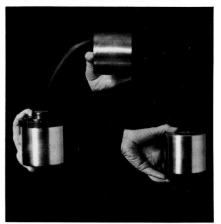

Rap tank sharply against the bottom of sink or working surface; agitate continually for first 30 seconds. Place tank in water bath and remove to agitate for 5 seconds every 30 seconds.

21 DUMP DEVELOPER

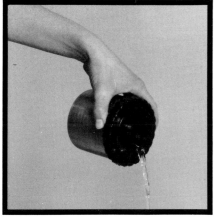

At end of the development time, remove small cap (not large lid) and dump developer out and discard.

22 SET TIMER

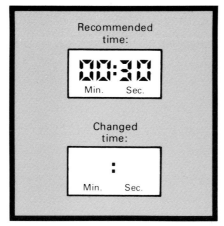

Recommended time:

00:30
Min. Sec.

Changed time:

:
Min. Sec.

Set your timer to 30 seconds.

23 ADD STOP BATH

Start timer. Tilt the tank and fill with stop bath, replace small cap and agitate continually.

24 DUMP STOP BATH

Remove small cap and dump stop bath back into storage bottle (it can be reused).

Processing your negatives
Developing

Processing your negatives: Fixing and rinsing

What's happening inside the tank?

After your film is developed and the action of the developer has been stopped by rinsing or using stop bath, the film is still sensitive to light. When fixer is poured in and agitated, it dissolves the remaining light-sensitive silver bromide crystals in the emulsion. Once these crystals are removed, the film can be safely exposed to light. Film should be fixed for the proper length of time since underfixing or overfixing can cause problems.

Underfixed negative If the film is fixed for too short a time, or in an exhausted solution, the negatives will have a milky purplish cast.

Properly fixed negative In a properly fixed negative, the fixer dissolves all the undeveloped silver bromide crystals without affecting the metallic silver image. The film edges are clear and the negative has good contrast.

Overfixed negative An overfixed negative will become bleached in time. A chemical reaction converts the silver into a compound that will dissolve the image. As you can see, the shadow detail (light areas on the negative) has been lost, and the negative has poor contrast.

How to dilute Hypo Clearing Agent to working strength			**1** Adjust water temperature to:	**2** Fill graduate with water to:	**3** Fill graduate with stock to bring level to:	**4** Stir until well mixed	**5** Pour into tank (see step 31 below)
If you want:	Dilution needed:	Start with:					
Hypo Clearing Agent (working strength)	1:4	Hypo Clearing Agent (stock)	68° F 20° C	15 oz. 470 ml.	18 oz. 510 ml.		
18 oz./510 ml. (enough for 2 rolls)		see p. 14 on how to mix stock solution					

Step by step

25 SET TIMER

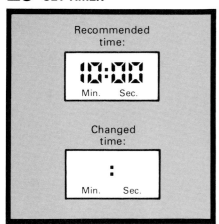

Set timer to 10 minutes.

26 POUR IN FIXER

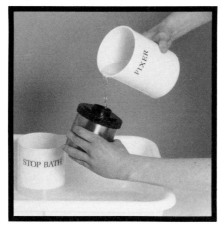

Start timer, tilt tank, and pour in fixer. Replace small cap.

27 AGITATE

Agitate tank continuously for first 30 seconds and then for 5 seconds out of every minute thereafter for 10-minute period.

28 DUMP FIXER

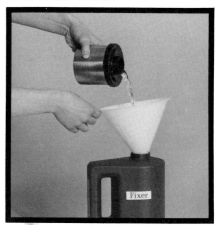

Now that the film is fixed, it can be exposed to light. Dump fixer back into its storage bottle (it can be reused).

29 RINSE

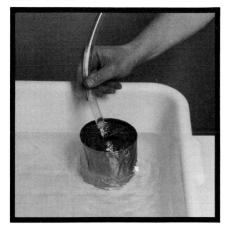

Rinse film in approximately 68°F (20°C) running water for 1 minute.

30 DILUTE HYPO CLEAR

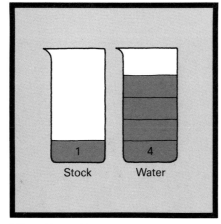

Dilute Hypo Clearing Agent stock solution to working strength (see above).

31 ADD HYPO CLEAR

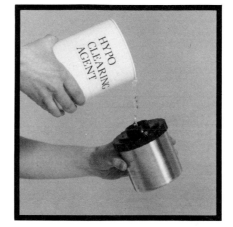

Dump water and add diluted Hypo Clearing Agent to tank, set timer to 1 minute. Secure the large tank lid and cap.

32 AGITATE AND DUMP

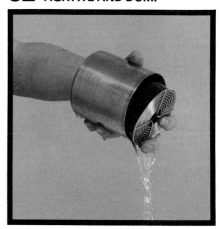

Agitate tank continually for 1 minute. Remove large lid, dump Hypo Clearing Agent and discard.

Processing your negatives
Fixing and rinsing

Processing your negatives: Washing and drying

TIPS
Washing film

Hypo Clearing Agent Hypo Clearing Agent (see p. 28 for dilution and use instructions) reduces washing time from 20 minutes to 5 minutes by more rapidly removing the sulfur residue left on the film from the fixer. This conserves water and the shorter washing time prevents the emulsion from swelling as much, reducing the risk of damaging your film while it is in this sensitive state.

Temperature Periodically check the temperature of your rinse water to be sure it hasn't changed. Using a dishwasher, washing machine, or even flushing a toilet can dramatically change the temperature of your rinse.

Hose A short hose can be fastened to your faucet and placed into the center of your reel to improve circulation. Your local hardware store should have the materials you need.

Film washer A film washer circulates water up and over the film more efficiently.

TIPS
Drying film

Wetting agents (Photo-Flo) After washing, you can just hang your film up to dry, but particularly in hard-water areas, the small drops of water may evaporate and leave a residue on the film. To reduce this possibility, you can immerse the film in a wetting agent for a minute. (See below for diluting instructions.)

TIPS
Filing film

Cutting your film Hold your film by its edges, count the correct number of frames your negative preservers are designed for (usually 5, 6, or 7), and cut the film squarely between the frames. It helps to use small scissors and to hold the film up to a light when cutting to place the cut accurately.

Labeling your film Assign a number to your negatives for future reference. Some photographers use a two-part number such as 82-12; the 82 standing for the year 1982, and the 12 standing for the 12th roll of film to be processed in 1982. Mark your number onto the negative preserver with a grease pencil or marking pen.

How to dilute Photo-Flo			1	2	3	4	5
If you want:	Dilution needed:	Start with:	Adjust water temperature to:	Fill graduate with water to:	Add 1 capful of Photo-Flo	Stir until well mixed	Pour into tank (see step 35 below)
Photo-Flo	1:200	Photo-Flo 200 (16 oz. bottle)	68° F 20° C	40 oz. 1200 ml.			
40 oz./1200 ml.							

33 EQUIPMENT NEEDED

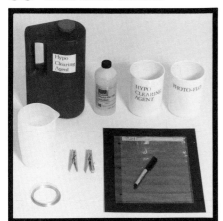

Hypo Clearing Agent, Photo-Flo, film clips, wire, negative preserver sheet, holding containers, graduate (32 oz), and pen.

34 WASH

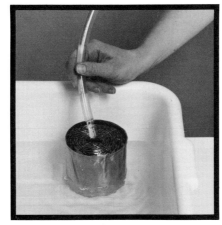

Wash film in running 68°F (20°C) water for 5 minutes. If you do not use Hypo Clearing Agent, wash film for 20–30 minutes and dump water from tank several times during washing.

35 ADD PHOTO-FLO

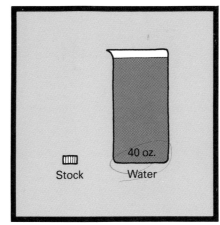

Dilute Photo-Flo (see above), dump water, and pour diluted Photo-Flo into tank. Swirl the solution around, then let it stand for about 30 seconds.

36 REMOVE REEL

Remove reel and film from tank and let it drain for a few seconds.

37 HANG FILM TO DRY

Attach one end of film to a film clip (or clothespin). Hang clip on wire or cord.

38 GENTLY UNWIND

Lower your hand, allowing the reel to rotate freely while the film unwinds. Remove reel from film end and attach another film clip to the bottom end to keep it straight while drying.

39 DRY AND CUT

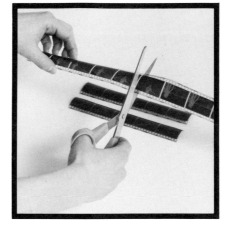

Allow the film to dry in a dust-free place, then cut it between the frames into strips of the appropriate length (see above).

40 INSERT AND LABEL STRIPS

Insert negative strips in numerical order and shiny-side-up into negative preserver and label it (see above).

Processing your negatives
Washing and drying

CHAPTER THREE
Making proof sheets in 3 steps

A proof sheet is a way to show positive prints of all 36 images from a roll of film on a single sheet of paper. A proof sheet is useful when evaluating and filing your negatives. Because the tones of a negative are reversed, it can be difficult to judge the quality. A proof sheet, on the other hand, provides a positive image that can easily be evaluated either directly or with a magnifying glass. Even experienced photographers prefer to work from a proof sheet rather than from the negatives themselves when deciding what to print.

A proof sheet is made by using a piece of glass or a proof printer to press the strips of negatives from a roll of film firmly against a sheet of enlarging paper. The enlarger then exposes the paper through the negatives.

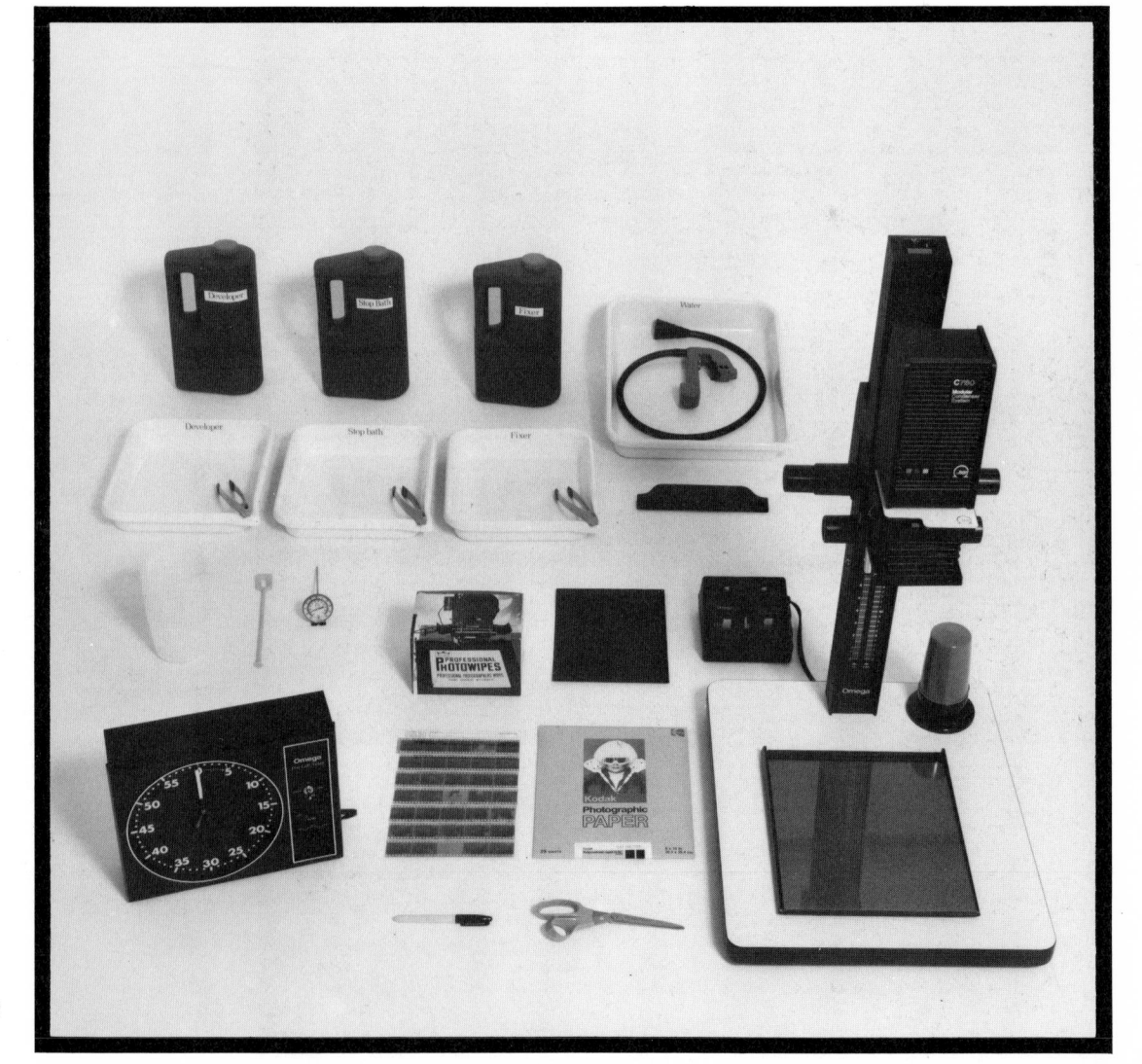

STEP 1: GETTING READY

> Equipment you'll need
> Setting up the wet side
> How your enlarger works
> Setting up the dry side

STEP 2: THE TEST STRIP

Making the exposures
Processing and evaluating

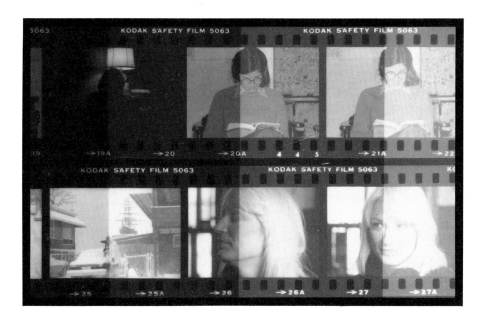

STEP 3: THE FINAL PROOF SHEET

Exposing and processing

Getting ready: Equipment you'll need

There are many similarities in making proof sheets and in making enlarged prints. Most of the equipment is the same, and the processing steps are identical. Most photographers set up their darkrooms so that they can make either proofs or enlarged prints at the same printing session, perhaps making proofs of their new negatives, then enlarged prints from either the new negatives or older ones. Organizing your darkroom sessions in this way reduces the amount of setup time required, making the sessions more enjoyable. The step-by-step sequences on setting up the wet side are covered in this chapter. In the following chapter on making enlarged prints, you can use the identical processing chemicals (developer, stop bath, and fixer) and processing steps.

Choosing a proof printer

Proof printers are used to hold your negatives firmly against the paper when making proof sheets, and are available in two styles. One style, used with transparent negative preservers, allows you to make a proof sheet without removing the negative strips. With the other style, you must remove each strip of negatives from their preserver sheet and attach it to clips on the proof printer.

Proof printers that are used with transparent negative preservers allow you to lay the entire sheet on the enlarging paper. The glass cover is then lowered to hold the entire sheet of negatives firmly against the paper while the exposure is made. This type of printer can also be used if the negatives are not in any type of holder.

Proof printers that require you to first remove each negative strip from its protecting sheet are a little more difficult to use. Each strip of negatives must be attached individually to clips in the proof printer before inserting the paper and lowering the glass cover.

Choosing your paper

The processing times in this book are based on your using glossy Kodak RC II paper, which is widely available and very popular. It is ideal for making proof sheets since its glossy finish allows you to see fine details. It is also a variable contrast paper, allowing you to use filters to change print contrast when making enlargements as discussed in Chapter 5 of this book. Other papers are available and you should experiment with them once you have the basics of printmaking well understood. If you do decide to experiment, here are some things to consider when buying paper.

RC (resin-coated) or conventional fiber-based paper?
RC paper is coated with a resin layer that acts as a barrier preventing processing chemicals from seeping into the paper base. The chemicals penetrate only into the very thin light-sensitive emulsion making processing and washing times shorter than those required for fiber-based papers, which lack this resin barrier. Many photographers, however, prefer fiber-based papers despite the longer processing and washing times since they are available in a much wider variety of surfaces and image tones.

Variable contrast or graded papers?
The contrast of your print (see page 76) can be controlled by changing the contrast of your paper. Graded papers are available in contrast grades from 1–5 (the higher the number the higher the contrast) but you have to buy a box of each to have complete control. Variable contrast papers require that you buy only one box of paper and a set of variable contrast filters (see p. 77) to have complete range of contrast from 1–5 in half grade steps, i.e., 1, 1½, 2, 2½, 3, 3½, 4, 4½, and 5.

Size Papers are available in a wide variety of sizes ranging from 3 × 5 to 16 × 20. The most popular size for both proofs and prints is 8 × 10.

Weight RC papers are all the same weight (medium) but fiber-based papers come in single weight (thin) and double weight (medium).

Surface texture and image tone
Papers vary widely in their surface and color characteristics. Your camera store will usually have a sample book that you can look at when choosing your paper.

Quantity Enlarging paper is packed in boxes holding anywhere from 10 to 500 sheets. Always buy small quantities until you know you like the paper, then buy in larger quantities to save money.

Equipment you'll need

Wet side

1 **Dektol (stock solution)**
2 **Stop bath (working strength)**
3 **Fixer (working strength)**
4 **32 oz (1 l) graduate**
5 **Trays (three)**
6 **Print tongs**
7 **Stirring rod**
8 **Thermometer**
9 **Print washer (tray with tray siphon)**
10 **Squeegee**
11 **Timer (or clock with sweep second hand)**

Dry side

12 **Negatives in preserver**
13 **Marking pen**
14 **Lint-free tissue (or lens cleaning tissues)**
15 **Black cardboard**
16 **Printing paper**
17 **Scissors**
18 **Proof printer**
19 **Safelight**
20 **Timer (for enlarger)**
21 **Enlarger and lens**

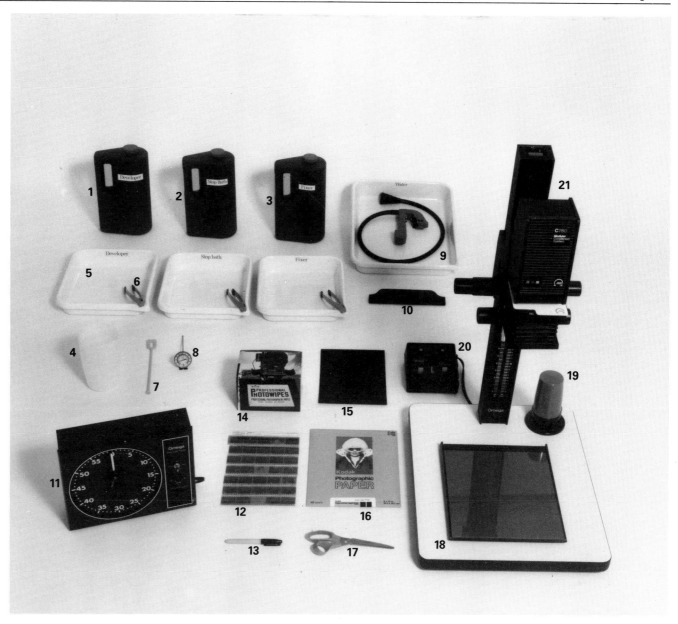

STEP 1 (cont.)
Getting ready: Setting up the wet side

The quality and consistency of your proof sheets and prints depends in part on the care you take when diluting chemicals and controlling temperatures. Processing proof sheets and prints, like developing negatives, is essentially a chemical process, although one that is less sensitive to small variations. Your results will be affected by variations in temperature, carelessness in dilutions, and contamination of one solution by another. Take the time to set up the wet side as carefully as possible.

The print processing sequence

Step 1 Developer makes the latent image appear on the exposed paper.

Step 2 Stop bath stops the action of the developer and lengthens the useful life of your fixer.

Step 3 Fixer removes the undeveloped silver left in the print after development and allows the image to be exposed to light without being affected by it.

Step 4 Washing removes the residue left in the print after processing and protects the print from deteriorating over a long period of time.

How important is temperature?

Most manufacturers have designed their chemicals and papers to work best at 68°F (20°C), but variations of a few degrees from this temperature are not important. As temperatures change, however, the rate at which chemical reactions occur also change. A print developed at 68°F (20°C) for 1 minute will be slightly lighter than one developed for the same length of time at a higher temperature. For this reason it's best to aim at a consistent temperature, at least between the time you make a test strip and the final print.

The temperature of the developer is the most critical. The tips at the right should help you adjust it as close to 68°F (20°C) as possible.

TIPS
How to adjust temperatures

Check the thermometer frequently when cooling or heating a solution. Even a brief period of time can result in considerable change.

If your temperature is too high
A good way to cool your developer once it is in the tray is to put ice cubes and water in a stainless steel container (such as your film developing tank) and put the container in the solution to be cooled.

If your temperature is too low
To warm your developer, place a stainless steel container (such as your film developing tank) filled with hot water into the tray. Stir the developer with your developer tongs to warm the solution evenly.

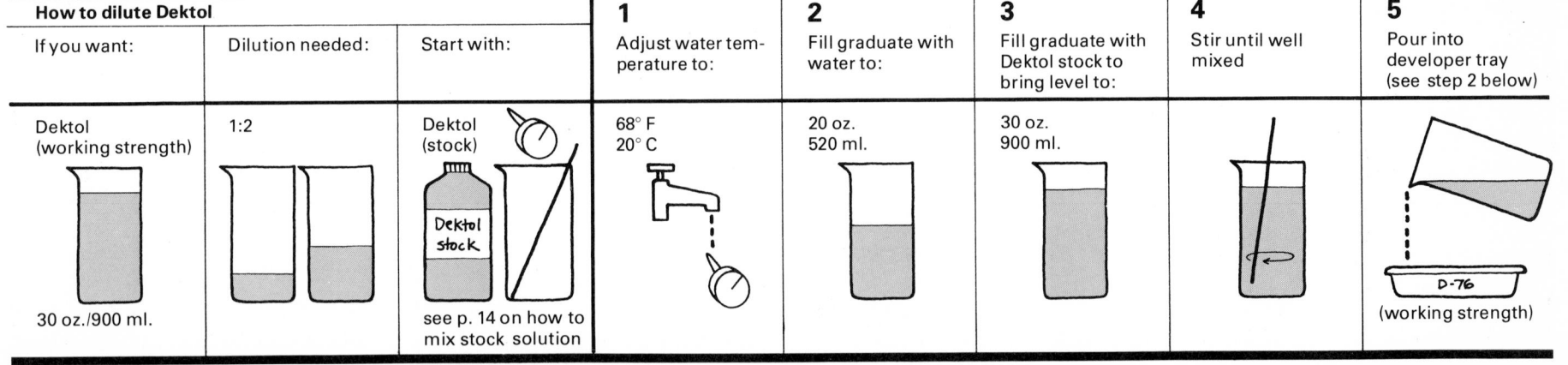

How to dilute Dektol			1	2	3	4	5
If you want:	Dilution needed:	Start with:	Adjust water temperature to:	Fill graduate with water to:	Fill graduate with Dektol stock to bring level to:	Stir until well mixed	Pour into developer tray (see step 2 below)
Dektol (working strength) 30 oz./900 ml.	1:2	Dektol (stock) Dektol stock see p. 14 on how to mix stock solution	68° F 20° C	20 oz. 520 ml.	30 oz. 900 ml.		D-76 (working strength)

Step by step

1 EQUIPMENT NEEDED

Storage bottles of Dektol, stop bath, fixer, graduate, thermometer, 3 trays and 3 tongs, print washer (or tray with tray siphon), squeegee, and stirring rod.

2 DILUTE DEVELOPER

Stock | Water

Dilute Dektol 1 part stock to 2 parts water (see above) and pour into developer tray.

3 FILL STOP BATH TRAY

Pour into stop bath tray about 32 oz (1 l) of working strength stop bath (see p. 15 for instructions on how to prepare).

4 FILL FIXER TRAY

Pour into fixer tray about 32 oz (1 l) of working strength fixer (see p. 15 for instructions on how to mix).

5 SET UP WASHER

Place a washing tray in or near a sink and attach tray siphon if you have one. Half fill tray with water at between 65°–75°F (18°–24°C).

6 CHECK TEMPERATURE

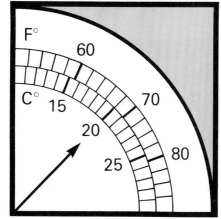

Developer should be 68°F (20°C), other solutions 65°–75°F (18°–24°C).

7 ADJUST TEMPERATURE

Adjust developer temperature if needed (see above).

8 WASH AND DRY HANDS

Thoroughly wash and dry your hands before you begin to set up your enlarger as shown on the next page.

Getting ready
Setting up the wet side

Getting ready: How your enlarger works

Your enlarger represents the single largest investment you will make in your darkroom and should be purchased only after considering your present as well as your future needs. Consider your negative format and also whether you will eventually want to make color prints. Some enlargers can be used only for 35mm negatives; others can also be used with 2¼ in (6 cm) medium format and larger negatives. If you decide to use a larger format camera at some time, you want to be sure your enlarger can handle its negative size. Most enlarger models can be adapted to make color prints. If you think you may want to make color prints at some time, make sure your enlarger will accept the necessary filters or has a color head available to replace the condenser head that comes with it.

Your enlarging lens

Your enlarging lens works just like the one on your camera. It contains an aperture the size of which can be changed by moving the aperture ring on the lens. This ring, marked in f-stops, controls the amount of light that will reach the paper. At smaller apertures (larger f-numbers) the print will be lighter, and at larger apertures (smaller f-numbers) it will be darker assuming that exposure time remains unchanged.

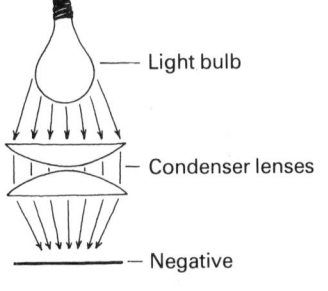

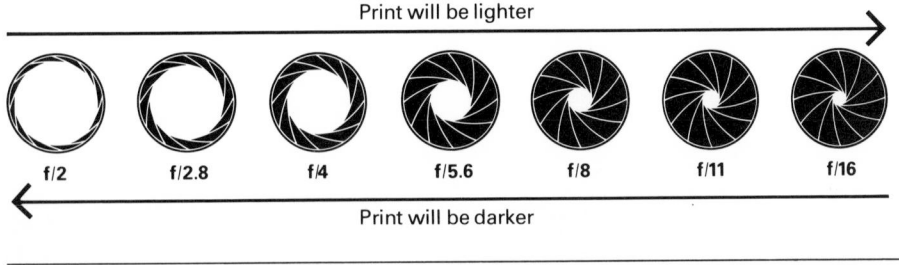

Your enlarger's light source

Two commonly available types of enlarger light sources are condenser and diffusion. Condenser sources (most frequently used for black-and-white printing) give a very sharp image but tend to emphasize dust and other negative imperfections. Diffusion sources (found primarily on color enlargers) give a softer, more diffuse light that tends to minimize negative imperfections. Although either source can be used to make black-and-white or color prints, your choice should be made on the basis of which kinds of prints you will make most frequently.

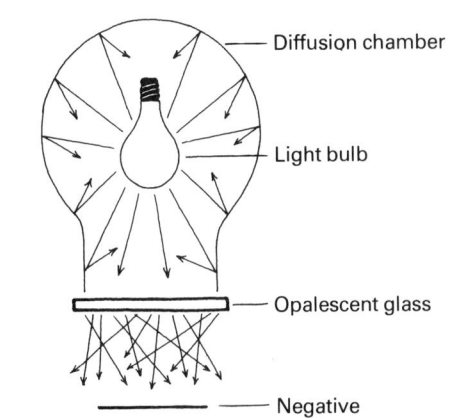

Condenser sources use a lens to focus the light from the bulb onto the negative plane. Because the light from the bulb is focused when it reaches the negative, the image is sharp and imperfections in the negative are clearly seen on the print. Its disadvantage of emphasizing imperfections is overridden by its ability to give sharp images and short printing times. It is the most common light source for black-and-white printing.

Diffusion sources have a highly diffused light. Either frosted or opalescent glass is inserted in the light path or the light is bounced back and forth in a mixing chamber to scramble it. Both methods result in a light that is scattered when it reaches the negative, resulting in a softer image on the print. This softness tends to hide imperfections in the negative so they are less obvious on the print.

Your enlarger parts

The enlarger column provides a track on which the enlarger head moves up or down as you turn the carriage crank. Some models have one column and others two, but the design, rather than the number, is what governs the stability of the enlarger head.

The enlarger head contains the light bulb, the condenser lenses (in a condenser enlarger), the mixing chamber (in a diffusion enlarger), the negative carrier to hold your negatives, the focusing assembly, and the enlarging lens.

The film stage opens so you can insert the loaded negative carrier.

The negative carrier isolates the chosen negative from the strip, holds it flat, and centers it under the enlarger light source.

The lens focuses the image from the negative onto the baseboard and its aperture adjusts the amount of light emitted and therefore can be used to control how dark or light the print will be.

The carriage lock locks the enlarger head in place once the image size you want has been obtained.

The baseboard provides a stable foundation for the enlarger and a place to put your proof printer or enlarging easel when making prints.

Your enlarger controls

The filter drawer accepts variable contrast filters which expand or contract the contrast of a print when used in conjunction with variable contrast paper (for more on contrast, see pp. 76–77). It also accepts color printing (CP) filters so that the enlarger can be used to make color prints. A piece of heat-absorbing glass is also used in color printing.

The lens aperture has a series of f-stops, just like your camera lens does. These control the amount of light passing through the lens. One of these f-stops, usually 1 or 2 stops wider than the smallest aperture on the lens, will give maximum sharpness and most photographers use one of these for most printing. The lightness or darkness of the print is then controlled by the amount of time the paper is exposed.

The focus control knob adjusts the sharpness of the projected image. It does so by changing the distance between the negative and the lens, just as your camera lens adjusts focus by changing the distance between the lens and the negative in the camera.

The elevation control changes the image size on the baseboard by changing the distance between the enlarger lens and the baseboard.

Getting ready: Setting up the dry side

Making your first test proof sheet takes longer because you have some experimenting to do. You have to find out how high the enlarger head should be to cover the proof printer with a circle of light, the correct aperture to use, and how long to expose the paper to get a properly exposed print. You don't have to experiment every time, however, if you make a complete record of the settings and adjustments you have made. This section shows you how to set up your dry side and record the most important information so that the second set of proof sheets can be made much faster.

How to standardize your proof sheets

Making standardized proof sheets is easy; once you have determined the best enlarger settings to use, they can be used over and over again. Don't adjust exposures to compensate for variations in negative quality. This avoids the real issue of poor negative exposure or development. Standardized proof sheets allow you to identify your real errors so that you can compensate when taking new pictures or making prints from current negatives.

Throughout this chapter you will see how to determine the best exposure settings. In the meantime, copy the label at right and tape it onto your enlarger or darkroom wall. Later you can record the exposure data in the spaces provided and mark the height of the enlarger head on the column. The next time you need to make a proof sheet, all the necessary information will be available.

To make proof sheets

ENLARGER HEIGHT
(LENS TO BASEBOARD):
_____inches

LENS APERTURE: f/_____

LENS FOCAL LENGTH: ____mm

EXPOSURE TIME: ____seconds

DEVELOPER USED:_____

DEVELOPMENT TIME: ____minutes

PAPER USED: _____

PAPER GRADE OR
POLYCONTRAST
FILTER USED: _____

What happens when you expose a proof sheet?

The emulsion side of the negatives is pressed firmly against the emulsion side of the paper by a piece of glass in the proof printer. When the enlarger is turned on, the paper is exposed through the negatives. The dark portions of the negative block much of the light and the light portions of the negative let most of it through to the paper. When developed, those portions of the paper that received the most light are darker than the portions where much of it was blocked. In this way the negative image becomes a positive image with the tones representing the way the scene originally looked when the picture was taken.

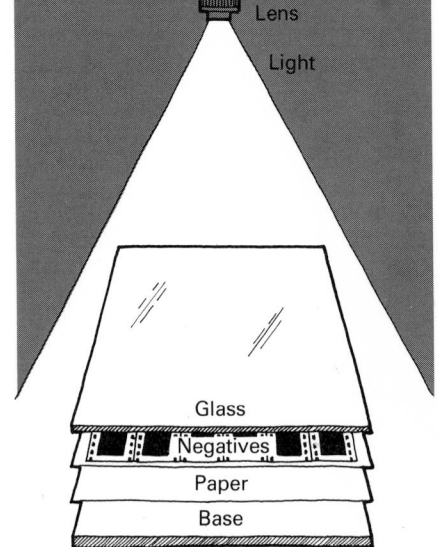

Why focus the enlarger?

You should focus your enlarger when making proofs, since the amount of light reaching the proof printer (and hence how light or dark the proof sheet will be) depends to some extent on where the lens is focused. To keep everything consistent from proof sheet to proof sheet you should set the enlarger head at the same distance from the baseboard, and focus the image. Do this by inserting your negative carrier in the enlarger and focusing until the projected shape of the carrier's edges are sharp.

Step by step

9 EQUIPMENT NEEDED

Proof printer, paper, negatives, a piece of black cardboard, tissues, marking pen, scissors, enlarger, and timer.

10 CLEAN PROOF PRINTER

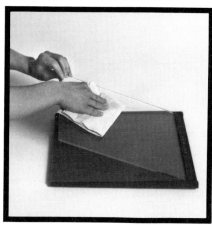

Carefully clean both sides of the glass on the proof printer with tissues, plus lens cleaner or plain water.

11 SET APERTURE

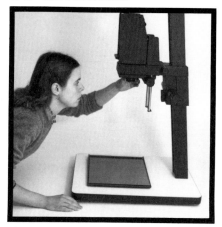

Set the lens aperture to f/11.

12 ADJUST ENLARGER

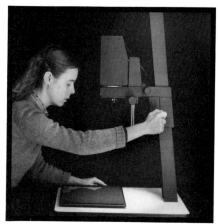

Turn enlarger on (and room lights off to help focusing) and move enlarger head up or down the column until the cone of light covers an area larger than the proof printer.

13 FOCUS ENLARGER

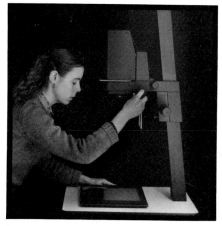

Insert an empty negative carrier into the enlarger and bring its edges into focus. Remove the negative carrier.

14 CHECK PRINTER POSITION

Check position of your proof printer to be sure it's centered and all four corners are within the circle of light projected by the enlarger. Turn enlarger off.

15 MARK HEIGHT

Turn room lights on. Mark the height of the enlarger head on the enlarger column.

16 SET TIMER

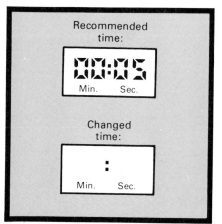

Set your enlarging timer for the first exposure of 5 seconds. Turn room lights off.

Getting ready
Setting up the dry side

The test strip: Making the exposures

The test strip is the method most commonly used to determine the proper exposure time needed to get the ideal print density (see p. 58) while making proofs or enlargements. Finding the best exposure is essentially a process of trial and error, but the test strip makes the search easy and inexpensive. A test strip is made by exposing successive portions of a small piece of paper for different lengths of time. The strips exposed for short periods will be lighter than those exposed longer. By carefully examining the series, the best exposure time can be identified and used to make the final proof sheet.

What is a test strip?

A test strip like the one to the right shows a consecutive series of bands of decreasing exposure. In this case, each band received exactly twice as much exposure as the next lighter one below it and exactly half as much as the next darker one above it. The amount of exposure each strip receives is determined by the time each was exposed (you could also vary the size of the aperture and keep the time constant, but most photographers prefer to vary the time). The best time in this example is the one at 20 seconds since it shows detail in both the highlight (light areas) and shadows (dark areas). See p. 44 on how to evaluate your test strip.

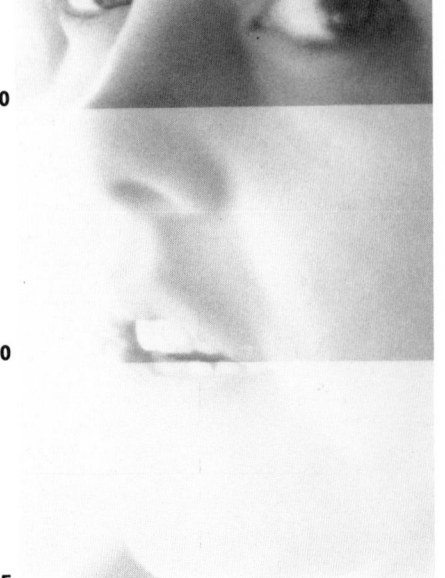

Finding the emulsion side

To open the package of paper, break the seal and open it only in the dark or under the appropriate safelight. Once it is open, you will find the sheets in an inner wrapping of black paper or plastic, or inside a black plastic bag. Open this inner wrapping carefully to remove your sheets of paper; you will have to refold it to replace the unused paper back into the package. Without this inner wrapping, the paper can become fogged from light seeping in along the edges of the package.

It is important to have the emulsion side of the negative in contact with the emulsion side of the paper when making contact prints. Here's how to identify the emulsion side under dim safelight:

Negatives tend to curl toward their emulsion side, which has a somewhat duller surface than the side without the emulsion.

RC (resin-coated) paper tends to curl away from the emulsion side very slightly, although this is sometimes hard to see. If in doubt, hold the paper up so that the light from the safelight reflects off the paper toward you: the shinier side is the emulsion side.

Fiber-based paper has a distinct curl toward the emulsion side. If your paper is older, this curl may be diminished so hold the paper up to the safelight: again, the shinier side is the emulsion side.

Step by step

17 CUT TEST STRIP

With safelights on and room lights off remove sheet of paper from its box. Cut strip about 2 inches wide off of one side. Return rest of sheet to box and close lid tightly.

18 LOAD PROOF PRINTER

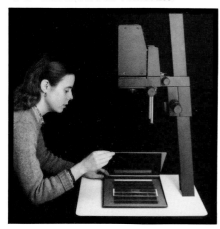

Put paper in proof printer emulsion side up. Align a row of negatives, emulsion side down, on top (see above on how to identify emulsion side). Close printer's glass lid tightly.

19 EXPOSE ENTIRE STRIP

Expose the entire strip for 5 seconds. The entire strip now has a total of 5 seconds exposure.

20 EXPOSE 4/5 OF STRIP

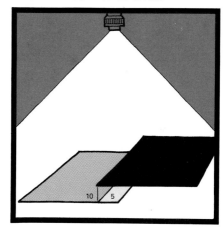

Cover 1/5 of strip, expose uncovered part for 5 seconds. The band covered by the card now has 5 seconds, the rest of the strip 10 seconds exposure.

21 EXPOSE 3/5 OF STRIP

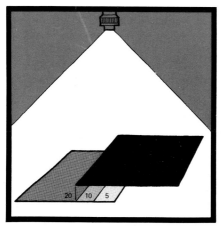

Cover 2/5 of strip. Expose uncovered part 10 seconds. The bands covered by the card still have 5 and 10 seconds and the uncovered portion 20 seconds of exposure.

22 EXPOSE 2/5 OF STRIP

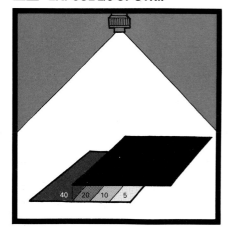

Cover 3/5 of strip. Expose uncovered part for 20 seconds. The bands covered by the card still have 5, 10, and 20 seconds of exposure and the uncovered part 40 seconds.

23 EXPOSE 1/5 OF STRIP

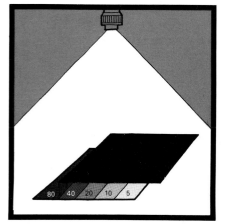

Cover 4/5 of strip. Expose uncovered part for 40 seconds. The strip now has bands of 5, 10, 20, 40, and 80 seconds of exposure. Remove strip from printer.

TIPS

If your test strip is too dark
Use an exposure sequence of 2, 2, 4, 8, and 16 seconds to get exposure bands of 2, 4, 8, 16, and 32 seconds. If still too dark, stop your lens aperture down 1 or 2 stops and try again.

If your test strip is too light
Use an exposure sequence of 10, 10, 20, 40, and 80 seconds to get exposure bands of 10, 20, 40, 80, and 160 seconds. If still too light, open up your lens aperture 1 or 2 stops and try again.

The test strip
Making the exposures

The test strip: Processing and evaluating

When you developed your negatives, all of the changes in the negative occurred in a tightly sealed tank where you couldn't see what was happening. But a developing print changes from a blank piece of paper to a photographic image before your eyes. The wonder of seeing the picture beginning to emerge in the developer tray is exciting even after thousands of prints have been made.

TIPS
Developing paper

■ Make sure your hands are clean and dry before handling paper and negatives. Any chemicals on your hands can stain or otherwise damage your prints or negatives.

■ Always drain your prints for a few seconds before moving them to the next processing tray. This will reduce the transfer of chemicals from one tray to the next and so prolong the life of your chemicals.

■ Always agitate each tray while the print is in it. Agitate continuously in the developer and stop bath, agitate frequently in the fixer. This will ensure even distribution of the chemicals over the print surface. Agitation is best done by gently rocking the tray.

■ Always develop the print for the recommended period of time. Underdevelopment will cause the print to be mottled; overdevelopment makes the print darker without improving it. If the final print is too light or too dark, make adjustments in your exposure—not in your development.

■ When putting your paper into the developer, slip it emulsion side up under the solution from one end of the print to the other like you would slip an envelope into a mail slot.

■ Try to reduce contamination by using print tongs to move prints from one tray to the next; avoid splashing or dripping one solution into another. Use the tongs to grip the print close to the edge, not in the middle. Tongs can sometimes leave scratch-like marks on the print.

Finding the best exposure time

When you look at your test strip, the first thing you may notice are the bands of various shades of darkness running across it. You may also notice how different pictures within the same band may be lighter or darker than others in the band. These variations from image to image are caused by variations in exposures in the camera. Nothing can be done about the variation in the negatives at this stage, but you need a more reliable guide to selecting the right exposure time for the entire proof sheet. In this case it's best to use the sprocket holes as a guide to the correct time.

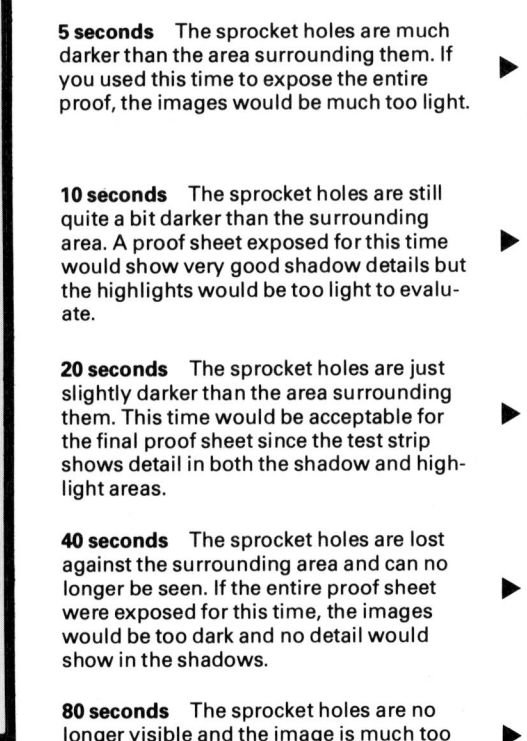

5 seconds The sprocket holes are much darker than the area surrounding them. If you used this time to expose the entire proof, the images would be much too light. ▶

10 seconds The sprocket holes are still quite a bit darker than the surrounding area. A proof sheet exposed for this time would show very good shadow details but the highlights would be too light to evaluate. ▶

20 seconds The sprocket holes are just slightly darker than the area surrounding them. This time would be acceptable for the final proof sheet since the test strip shows detail in both the shadow and highlight areas. ▶

40 seconds The sprocket holes are lost against the surrounding area and can no longer be seen. If the entire proof sheet were exposed for this time, the images would be too dark and no detail would show in the shadows. ▶

80 seconds The sprocket holes are no longer visible and the image is much too dark to be properly evaluated. ▶

Step by step

24 SET TIMER

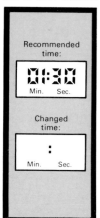

Set timer to 1½ minutes. Slip test strip into developer and start timer.

25 AGITATE

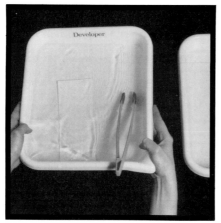

Gently agitate the developer by continuously rocking the tray during the recommended development.

26 STOP BATH

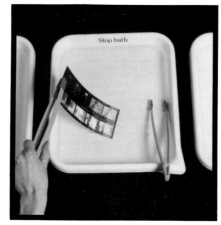

Remove test strip from developer with developer tongs, drain for a few seconds, and slip into stop bath. Don't let tongs touch the stop bath solution. Agitate for 5 seconds.

27 SET TIMER

Set your timer to 2 minutes.

28 FIX

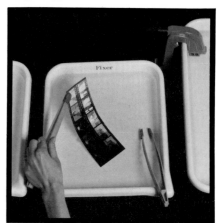

Use stop bath tongs to remove test strip from stop bath and drain briefly before placing in fixer. Start timer and agitate strip in fixer frequently during the full 2 minutes.

29 WASH

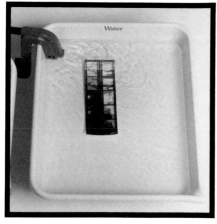

With room lights on, use fixer tongs to remove test strip from fixer and place it in wash tray. Wash for 4 minutes.

30 DRY

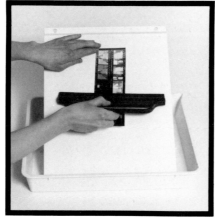

Remove test strip from rinse and squeegee off excess water.

31 EVALUATE

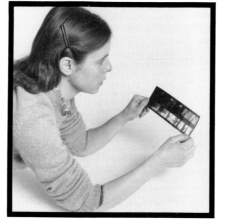

By looking at the sprocket holes under bright average room light, select best exposure time (see above) for final proof sheet. Enter time onto frame 33 on p. 47.

32 RECORD DATA

To save time when making your next proof sheet, make a label similar to that shown on p. 40.

The test strip
Processing and evaluating

STEP 3
The final proof sheet: Exposing and processing

After you have exposed and processed your final proof sheet, as shown below, you must wash and dry it before filing it away for reference. If you used RC paper for these prints as we recommend, this is a very fast and simple process. If you used fiber-based paper, the process is not more difficult but usually requires more steps and longer times. The tips below may help you when washing and drying any print.

TIPS
Washing your prints

■ RC paper's resin coating keeps processing chemicals and wash water from penetrating the base of the paper. As a result, it does not require as long a wash time as conventional fiber-based papers, where chemicals can readily penetrate into the paper. In fact, long wash times cause problems by allowing the water to soak into the edges of the paper causing damage to the print. Always follow the manufacturer's recommendations.

■ Because longer washing times are necessary for fiber-based papers, you should use Hypo Clearing Agent and a high-quality washer.

■ Washing prints removes chemicals that might lead to print fading or discoloring over a period of time. Complete washing is necessary if you want your prints to last.

■ Water circulation determines how effectively your prints are washed. Expensive print washers are available but many photographers use an inexpensive tray siphon. The siphon is designed to circulate the wash water over the surface of the prints while allowing new water to replace the chemical-laden old. Dump water occasionally so the tray refills with fresh water.

TIPS
Drying your prints

■ When drying prints it helps to allow the air to circulate on both sides. This reduces curling problems with fiber-based papers but also speeds the drying of RC papers. One method is to lay the prints on a fiberglass screen.

■ Drying time and water spots are both reduced if you squeegee your prints after washing. Lay the print flat, image side up, on a clean, flat surface such as a piece of glass and squeegee with a clean squeegee.

■ Dry RC papers emulsion side up, but place fiber-based papers emulsion side down to reduce curling.

■ You can use a hair dryer, at a low temperature, to speed print drying or you can lay the prints on a fiberglass screen on top of a portable dehumidifier if you have one.

TIPS
Filing your proof sheets and negatives

■ Assign a number to each proof sheet and its corresponding set of negatives to simplify the process of finding a particular image when your collection grows. (See p. 30.)

■ Negatives can be filed with their proof sheet in a binder or proof sheets can be in one binder and the negatives in another. As long as they are all numbered and filed in sequence, either system will work.

Step by step

33 SET TIMER

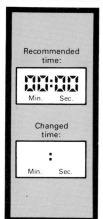

Recommended time:

00:00
Min. Sec.

Changed time:

:
Min. Sec.

Set your timer for the exposure indicated by the test strip.

34 LIGHTS OFF

OFF

Turn room lights off and safelights on.

35 LOAD PROOF PRINTER

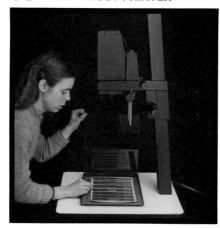

Place a full sheet of paper into proof printer, emulsion side up; place sheet of negatives, emulsion side down, on top of it. Align negatives with the paper, then close cover.

36 EXPOSE

Expose paper for the determined length of time (see step 33). Remove exposed sheet from printer.

37 DEVELOP

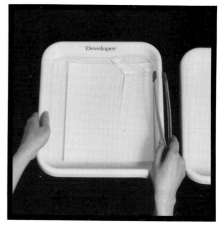

Set timer to 1½ minutes and slip exposed sheet of paper into developer. Agitate print for full development time.

38 STOP BATH

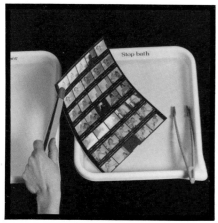

Using developer tongs, remove proof sheet from developer and drain briefly before slipping it into stop bath. Agitate proof in stop bath for 5 seconds.

39 FIX

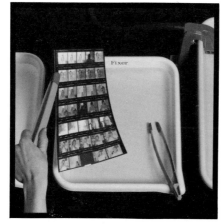

Remove proof sheet from stop bath and drain briefly before slipping it into fixer. Set timer to 2 minutes and agitate print frequently during fixing time.

40 WASH PROOF

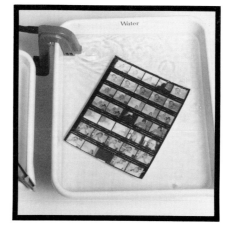

With room lights on, remove proof sheet from fixer, drain briefly, and slip it into wash tray. Wash it for 4 minutes (if not using RC paper see instructions packed with paper).

41 DRY AND LABEL

Remove excess water from print with a squeegee and air dry. Label it with same number you assigned your negatives.

The final proof sheet
Exposing and processing

CHAPTER FOUR
Making enlarged prints in 3 steps

Making enlargements is one of the most exciting aspects of photography. The images are no longer negatives being developed in a lightproof tank into which you can't see, or on proof sheets so small they look like postage stamps. For the first time the image is blown up large enough to see even the finest details and expressions.

Choosing a good negative to print is one of the first steps to making good prints, but even the best negatives can be improved. In this chapter you'll see how to select a negative to enlarge and how to make the best possible print.

Since most photographers set up their darkrooms to make proof sheets prior to making enlargements, this chapter assumes that you already have your chemicals diluted and in their trays. If not, see pp. 36 and 37 for how to set up the wet side.

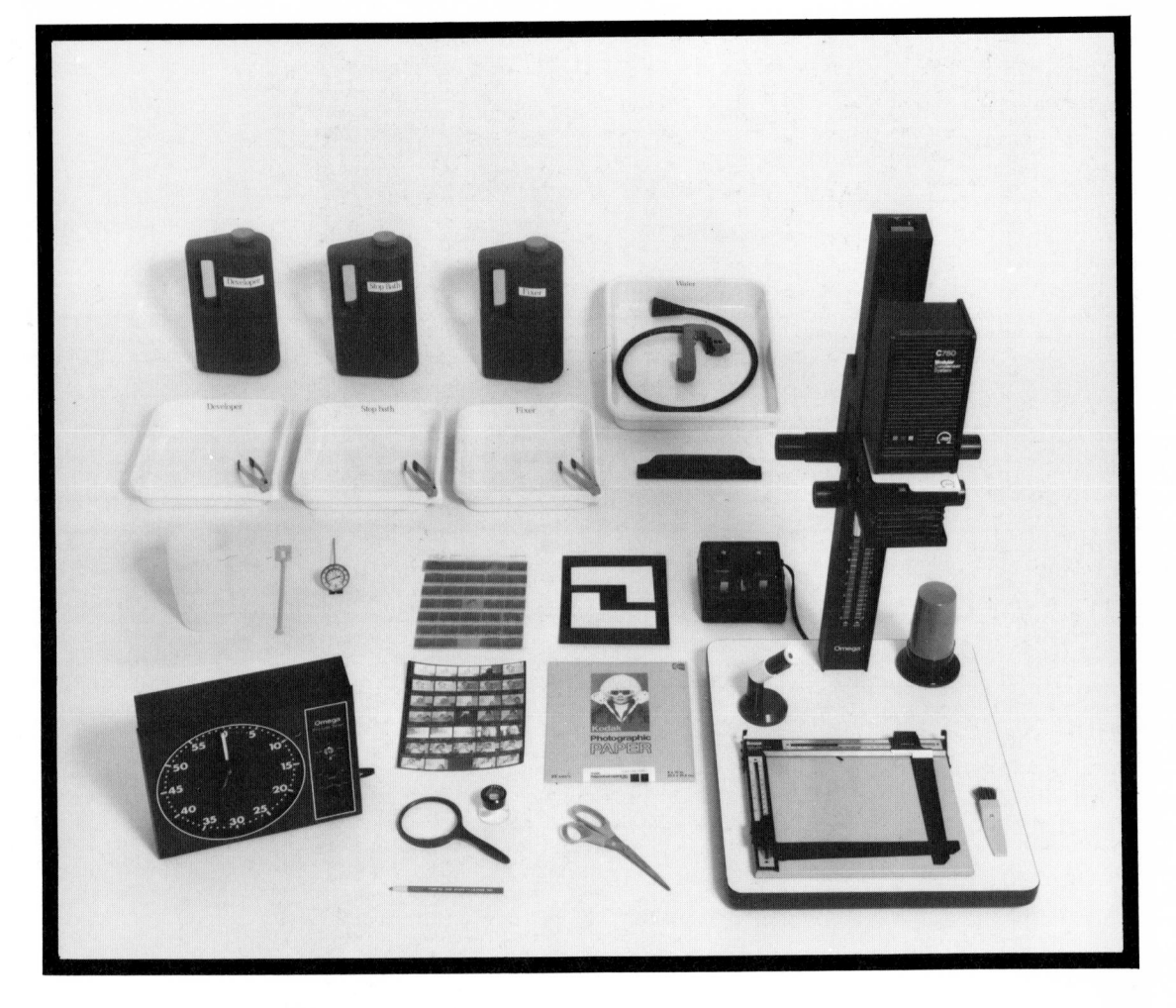

STEP 1: GETTING READY

Equipment you'll need
Choosing a negative
Setting up your enlarger

STEP 2: THE TEST STRIP

Making the exposures
Processing and evaluating

STEP 3: THE FINAL PRINT

Exposing and processing
Drying

STEP 1
Getting ready: Equipment you'll need

The same equipment that is used to make proof sheets is also used to make enlarged prints, with a few exceptions. In place of the proof printer you will use an enlarging easel to hold your paper. A grain magnifier is the only other piece of equipment you may want to use and it is not an absolute necessity.

Using a grain magnifier

When placed under the enlarger a grain magnifier enlarges a small part of the projected image, allowing you to see the actual grain structure of the film. This method is a much more reliable guide to focusing than using the image itself since parts of the image may or may not be in focus depending on how you set the camera when the picture was taken. When using a grain magnifier keep the following points in mind:

■ The magnifier should be resting on the same surface that you print on, since it's designed to bring that point into focus. Use a small piece of the paper you use for printing under the magnifier when focusing. If you always use the same kind of paper, you can glue the piece to the bottom of the magnifier.

■ Always focus at the aperture you plan to use for the print. Most lenses will shift focus slightly when the aperture is changed.

■ Refocus each time you make a print or test strip since the enlarger light

will heat the negative and it may buckle slightly. When the enlarger is turned off, the negative will cool and return to its original shape.

■ If you can't see the image through the eyepiece of the magnifier, move your eye position relative to the eyepiece. You have to look through the eyepiece at just the right angle.

■ Focus the image by using the focus control to go back and forth through the point of sharpest focus, narrowing the range of movement each time until you have the sharpest image possible.

Choosing an enlarging easel

An enlarging easel holds the paper flat and positions it under the enlarger while it is exposed. Most models also give the print a border and a clean, sharp edge to the top, bottom, and sides of your images. Other models are designed so that the full sheet of paper can be printed on without a border.

Single-size easels Easy to use because there are no movable blades. These easels will give only one image size on a sheet of paper. To change image size or shape you have to change easels.

Borderless easels Designed so that an image can be printed onto a sheet of paper without leaving a border around the edges.

Two-bladed easels The least expensive easel that permits you to change image shapes and sizes by moving a pair of movable blades.

Four-bladed easels The most expensive but most flexible style. These easels allow you to center images on a sheet of paper regardless of image size in relation to the sheet.

Wet side

1 Dektol (stock solution)
2 Stop bath (working strength)
3 Fixer (working strength)
4 32 oz (1 l) graduate
5 Trays (at least three)
6 Print tongs (three)
7 Stirring rod
8 Thermometer
9 Print washer (tray with tray siphon)
10 Squeegee
11 Timer (or clock with sweep second hand)

Dry side

12 Negatives and proof sheet
13 Magnifying glass or loupe
14 Grease pencil
15 Cropping "L's"
16 Black cardboard
17 Printing paper
18 Scissors
19 Printing easel
20 Negative cleaning brush
21 Safelight
22 Grain magnifier
23 Timer (for enlarger)
24 Enlarger and lens

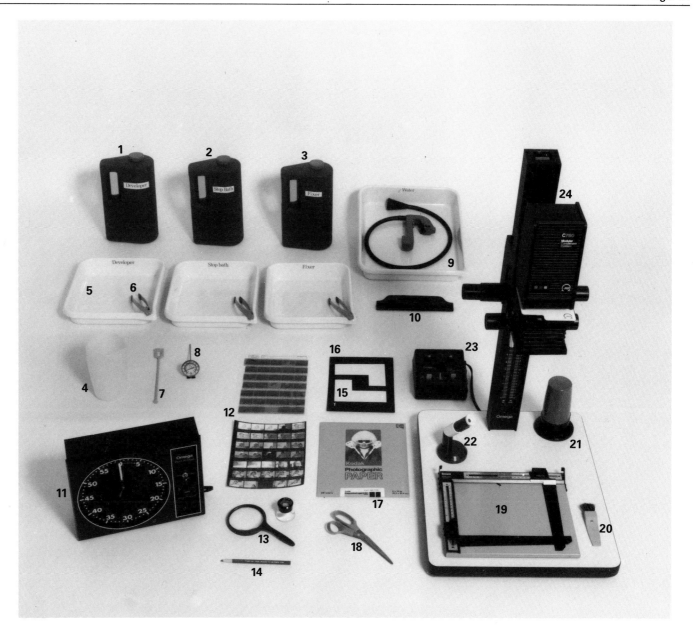

STEP 1 (cont.)
Getting ready: Choosing a negative

Experienced photographers can make great prints from almost any negative but the necessary skills may take a long time to learn. Your first prints should be made from the best negatives you have; the better the negative, the easier it will be to make a good print.

The viewing environment and equipment

The images on a proof sheet are so small that they should be studied carefully under ideal viewing conditions. Discovering obvious faults after a print is made is an expensive way to learn.

Daylight or bright artificial light should be used to evaluate proof sheets. Dim light or light from a safelight will make the images look much darker than they really are and will prevent you from seeing fine details.

Negatives and proof sheets should be used together when selecting a negative for enlargement. In some cases the proof sheet will show imperfections that are not actually on the negative but are caused by dust, water marks, or poor contact introduced when making the proofs. You can identify these by checking the proof against the actual negative.

Cropping L's help in eliminating the distracting elements around the image you are studying. They can also be used to determine how to crop an image (see opposite).

Magnifiers such as a magnifying glass or loupe will allow you to see the fine details on the proof. A magnifier makes it much easier to judge sharpness and other details that are hard to see unmagnified.

A grease pencil is very useful when you want to mark the negatives for enlargement and to indicate cropping. The markings can be easily wiped off the glossy surface of RC paper.

Using cropping "L's"

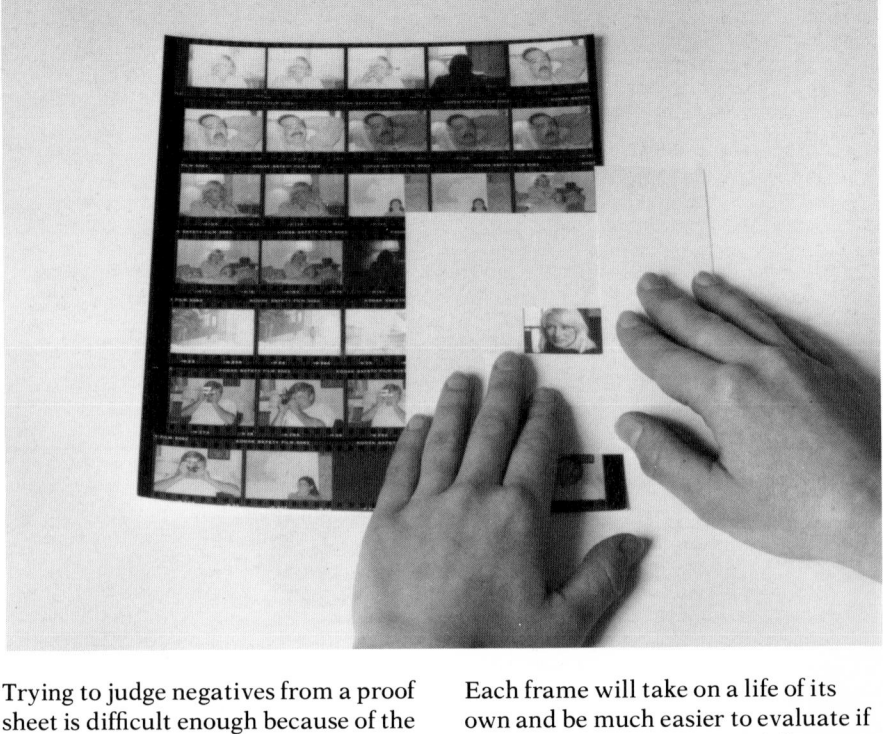

Trying to judge negatives from a proof sheet is difficult enough because of the small size of the images. It's made even harder because each image is surrounded by other images from the same roll of film. The other images in your field of view compete for your attention and subconsciously reduce the significance of any single image. Also, because most prints are viewed against a white background, the black background of the contact sheet can make them look different from how they will look in the final print.

Each frame will take on a life of its own and be much easier to evaluate if you use a set of cropping "L's" to isolate the single frame against a white background. Cut a pair of "L's" from an index card or any other piece of white paper. Arrange the "L's" around the image to isolate it from the other images on the page. Cropping "L's" can also be used to decide how to crop an image. For more on cropping, see p. 70.

■ ■

What to look for

Underexposed negatives lack details in the shadow areas of the scene (the thinner and lighter areas in a negative) and result in prints with a flat (low contrast) appearance. If you print an underexposed negative use a high-contrast paper (see p. 76).

Normally exposed negatives have good details in both the highlight and shadow areas. A normally exposed negative is the easiest to print well. Use a normal grade paper to print a negative such as this (see p. 83).

Overexposed negatives have good detail in the shadow areas but the highlights are blocked and appear very dark in the negative. If you print an overexposed negative use a low-contrast paper (see pp. 76 and 83).

Processing faults can seriously affect the quality of your image. Under- or overdevelopment, film sticking together, poor agitation, fingerprints, fogging, or chemical deposits can all ruin an image. Either try to fix the negative or avoid printing them altogether (see p. 82).

Overall sharpness is important unless you are deliberately trying to soften part of the image. Lack of sharpness cannot be corrected in printing (unless it resulted from poor contact between film and paper when your proof sheet was made; see p. 87). In the negative, it is caused by camera or subject movement, poor focusing, or insufficient depth of field.

Dust and scratches on the negative will appear on prints as light spots and dark or light lines. Always clean your negative carefully to remove dust before printing. Some negative scratches can be repaired (see p. 87).

Facial expression on the people in your pictures may not look very important in the very small proof sheet image but will often be the most important part of your enlargement. Use a strong magnifying glass to check expressions before printing.

Composition should be considered when choosing a negative. Although it's much better to compose carefully at the time the picture is taken, some improvement can be made by cropping the image (see above).

**Getting ready
Choosing a negative**

STEP 1 (cont.)
Getting ready: Setting up your enlarger

Once you have selected a negative to enlarge, the next step is to clean it, insert it in the enlarger, and adjust the enlarger to give you a sharp image the size you want.

Cleaning your negatives

Negatives always gather dust, especially since pulling your negative strip out of its plastic preserver can create a static electricity charge. This charge, much like the one you get by dragging your feet across a carpet on a dry day, attracts and holds dust on the negative's surface. Unless you remove this dust, the small dust particles will block the light from the enlarger and create small white spots on your prints.

How to see dust Put your negative into the negative carrier and hold it up so that light from the enlarger lamp or other source reflects off the negative's surface toward you. Gradually move the carrier around to shift the reflections. At certain angles the very small dust spots will be visible.

How to clean the negative with a brush Antistatic brushes are soft enough to clean a negative without scratching it while at the same time neutralizing the static charge that both attracts and holds dust. Always brush the negative gently while holding it at an angle so the dust won't fall back onto the negative. Be sure to clean both sides.

How to clean with a can of compressed air Cans of compressed air are available that are safe for negative cleaning. Hold the can upright and tip the negative slightly while depressing the valve on the can. Never shake the can or tip it while cleaning since this can cause propellant to reach your negative and cause serious damage.

Adjusting your easel blades

When using a two-bladed easel and a 35mm negative there are two givens:
1 The image projected by the enlarger of the negative is not exactly the same shape as your paper.
2 The left and top blades of your easel are fixed in position and won't move. If you want even borders on left, right, and top (and you want the largest image you can fit on the paper), you will have to adjust the bottom and right blades since they are the only ones that move.

How to get the largest print with even borders on left and right sides
1 Cut a piece of paper to the same size as the paper you plan to print on. Insert it into the easel.
2 Trace the left and top margins on the sheet with a pencil.
3 Remove the paper and measure the distance from the edge of the paper to the left margin line you drew in.
4 Measure this same distance in from the right edge of the paper and draw a line.
5 Reinsert paper into the easel and adjust the right easel blade so that it's flush with the right margin line you just drew in (step 4).
6 Position the easel under the enlarger and adjust the head up and down the column while adjusting the focus to get the image to fit into the left and right borders of the easel.

Image area / Paper area

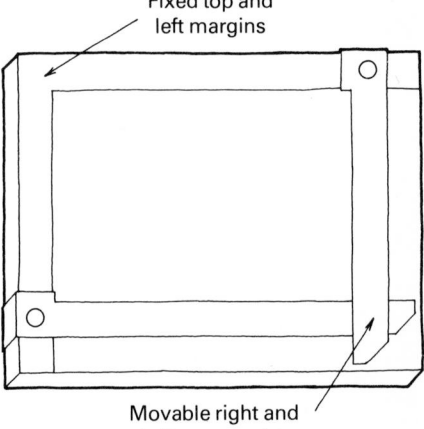

Fixed top and left margins

Movable right and bottom margins

7 Move the easel so the top margin just overlaps the image and move the bottom blade up to just inside the bottom area of the image.

Step by step

1 EQUIPMENT NEEDED

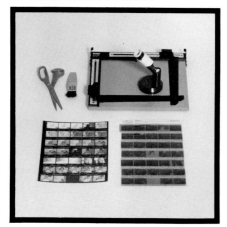

The same wet side equipment used to make proof sheets (see p. 23), plus: easel, negative cleaning brush, grain magnifier, proof sheet, negatives, and scissors.

2 LOAD NEGATIVE

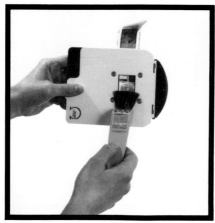

Clean negative with negative brush and place it into negative carrier, emulsion side down (see p. 42 on how to identify emulsion side).

3 TURN LIGHTS OFF

Turn safelights on and room lights off to make projected image easier to see.

4 TURN ENLARGER ON

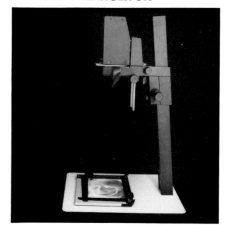

Turn on the enlarger and open the aperture all the way to give the brightest possible image.

5 ALIGN EASEL

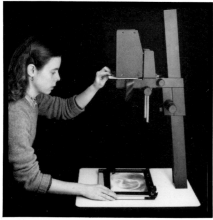

Move negative carrier and easel to align image horizontally and vertically on easel.

6 ADJUST IMAGE SIZE

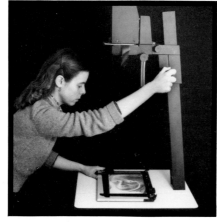

Center easel under enlarger and adjust image within easel blades or frame. Use both focus and elevation controls (see above) to give desired image size.

7 STOP DOWN APERTURE

Stop the lens down to f/8 or f/11, probably your sharpest apertures.

8 FOCUS

Check the focus one last time and be sure it's as sharp as you can get it. Turn enlarger off.

Getting ready
Setting up your enlarger

STEP 2
The test strip: Making the exposures

The purpose of a test strip is to help you determine the proper exposure to use for your final print. The test strip should expose both highlight and shadow areas so that both can be evaluated for density and contrast (see p. 58). The best exposure times to use depend on the brightness of your enlarger light, its distance from the test strip, and the speed of your paper (how sensitive it is to light). If your results using the times suggested on this page are too dark or light, see the tips below on how to adjust your exposures.

Placing the test strip: Method 1

If the most critical area of the print (containing both highlight and shadow areas) is large enough (as in the photograph at right) you can make a test strip on a single piece of paper. After exposing as shown below and processing, the test strip will contain bands of exposures for 5, 10, 20, 40, and 80 seconds.

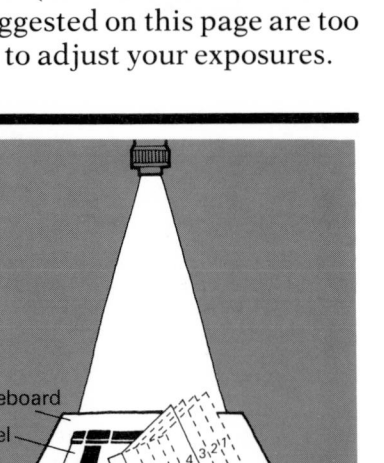

Baseboard
Easel
Test strip

Placing the test strip: Method 2

If the most important area of the print is too small to use a single test strip, cut five small pieces of paper, place them in the same position (covering the most important area), and expose the first for 5 seconds, the second for 10, the third for 20, the fourth for 40, and the fifth for 80 seconds. After processing you will have a series of identical test prints ranging from 5 seconds (light) to 80 seconds (dark).

5 **10**

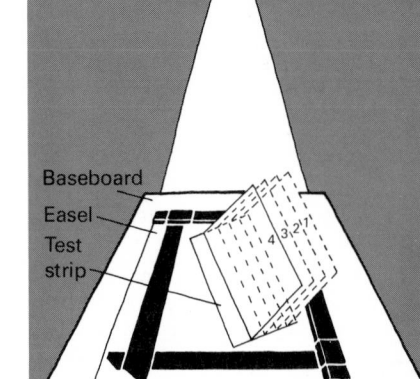

20 **40**

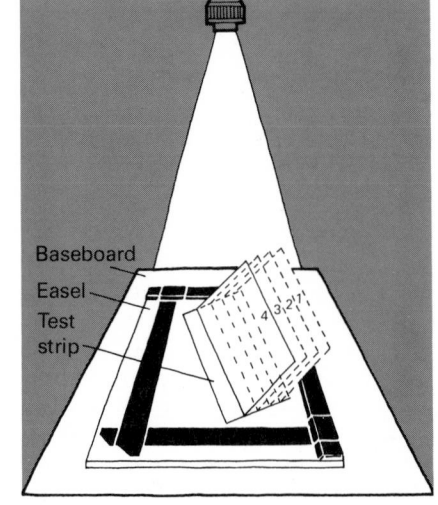

80

Baseboard
Easel
Test strips

Same place
5 times

9 CUT TEST STRIP

With room lights off and safelights on, remove a sheet of paper from its box. Cut a strip about 2 inches wide off of one side. Return rest of sheet to box and close lid tightly.

10 PLACE STRIP IN EASEL

Place unexposed test strip into easel positioned so it will cover most important highlight and shadow areas (see above). Use easel blade to hold strip in place if possible.

11 EXPOSE ENTIRE STRIP

Expose entire strip for 5 seconds. The entire strip now has a total of 5 seconds exposure.

12 EXPOSE 4/5 OF STRIP

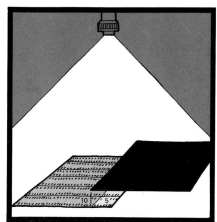

Cover 1/5 of strip, expose uncovered portion for 5 seconds. The band covered by the card now has 5 seconds, the rest of strip 10 seconds exposure.

13 EXPOSE 3/5 OF STRIP

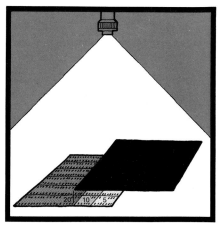

Cover 2/5 of strip, expose uncovered portion for 10 seconds. The bands covered by the card now have 5 and 10 seconds, the uncovered portion 20 seconds exposure.

14 EXPOSE 2/5 OF STRIP

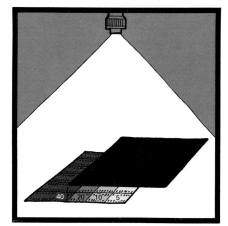

Cover 3/5 of strip, expose uncovered portion for 20 seconds. The covered bands now have 5, 10, and 20 seconds of exposure, the uncovered portion 40 seconds.

15 EXPOSE FINAL 1/5 OF STRIP

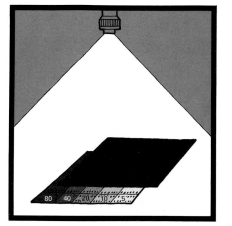

Cover 4/5 of strip, expose uncovered portion for 40 seconds. The strip now has bands of 5, 10, 20, 40, and 80 seconds of exposure. Remove exposed test strip from easel.

TIPS

If your test strip is too dark
Use an exposure sequence of 2, 2, 4, 8, and 16 seconds which will give you exposure bands of 2, 4, 8, 16, and 32 seconds. If still too dark, stop your lens aperture down 1 or 2 stops and try again.

If your test strip is too light
Use an exposure sequence of 10, 10, 20, 40, and 80 seconds to get exposure bands of 10, 20, 40, 80, and 160 seconds. If still too light, open up your lens aperture 1 or 2 stops and try again.

The test strip
Making the exposures

The test strip: Processing and evaluating

After processing the test strip as shown in the step-by-step sequences below, it should be washed briefly and evaluated. Evaluate in an area where the light is normally bright; very dim light makes prints look darker than they do under normal viewing conditions. A very bright light used very close to the print makes it appear lighter than it will under normal conditions. The test strip should be evaluated for density and contrast.

Print density

"Density" refers to how much silver has been deposited in an area of a negative or print and so how light or dark that area is. The denser the silver the darker the area. The density of negatives and prints is controlled by the amount of light to which they are exposed. In your test strip, the parts that were exposed for longer periods are denser and darker than the ones exposed for shorter lengths of time.

The first thing to look for on your test strip is the band where the highlights (light areas) appear correct in tone. They should show some detail without having a gray, muddy tone. The exposure band that has highlights of this quality indicates the exposure time you should use for your print.

On the strip at right the 20-second band shows good highlights with detail showing. The 10-second band shows clear highlights without any details, and the 30-second band shows the details but has a muddy, veiled look to it.

Print contrast

"Contrast" describes the difference in brightness in a print or negative between the highlights (light areas in the original scene) and shadows (dark areas in the original scene). For details on how to control the contrast of your prints, see pp. 76–77.

Print from high-contrast negative ▶
A print from a high-contrast negative appears harsh with very dark shadows, very light highlights, and few middle gray tones. High-contrast negatives usually result from too great a subject brightness range (bright sun and deep shadows on snow, for instance), or from overdevelopment of the negative.

Print from normal negative ▶
Normal negatives give prints with a full range of tones including pure whites and pure blacks and rich middle grays. Details appear in both shadow and highlight areas.

Print from low-contrast negative ▶
Prints from low-contrast negatives have a flat appearance and lack a full range of tones. They rarely have either pure blacks or pure whites. Almost all of the tones are from the middle grays. Low-contrast negatives result from a flat subject (fog-covered scenes, for instance) or underdevelopment of the negative.

Step by step

16 SET TIMER

Recommended
time:

01:30
Min. Sec.

Changed
time:

:
Min. Sec.

Set timer to 1½ minutes (or watch wall clock sweep second hand to time development).

17 DEVELOP

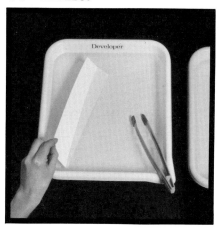

Slip paper into developer, start timer, and agitate test strip for entire development time.

18 STOP BATH

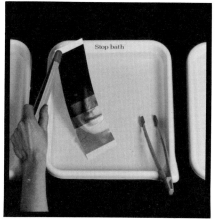

Using developer tongs, remove print from developer, drain briefly and slip into stop bath. Agitate for 5 seconds.

19 FIX

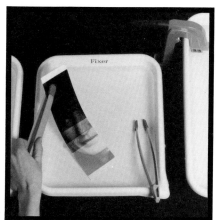

Remove print from stop bath with stop bath tongs, drain, then place in fixer.

20 AGITATE

Agitate test strip continuously while it is in the fixer for 2 minutes.

21 DRAIN AND WASH

Turn room lights on, remove test strip from fixer with fixer tongs and wash in running water for 2–4 minutes.

22 DRY

Remove test strip from rinse, drain briefly, and squeegee off excess water.

23 EVALUATE

Evaluate test strip for density and contrast to select best exposure time (see above).

The test strip
Processing and evaluating

The final print: Exposing and processing

Always process your prints for the times recommended by the manufacturer. Changing print development times has no useful effect on your images. Overdeveloping your prints will only make them darker and won't improve contrast. Underdeveloping will make your prints lighter but will also result in their being flat and perhaps mottled.

Changing the manufacturer's recommended fix or wash times can damage your prints. This damage may not be immediately apparent but will definitely become noticeable over a period of months or years.

How long do you wash prints?

After your print comes out of the fixer, it can be safely exposed to light but thorough washing is required to remove all of the chemicals and residues of the processing cycle. If these are not completely removed, your image will eventually become stained and/or faded.

Remember that all washing times are measured from when you put your last print into the washer. If one sheet of RC paper has washed 3 minutes and you then put another sheet into the washer direct from the fixer, you have to wash both prints for 4 more minutes since the first one has been contaminated by the second. This can extend the wash time for the first print past the point where damage may be done to its surface. The kind of paper you use and your print washing setup also affect wash times.

Paper Each paper brand has its own washing characteristics, but the major differences are between RC and conventional fiber-based paper. RC paper has a resin coating that prevents chemicals from seeping into the paper base. This coating shortens washing times since the wash doesn't have to rinse chemicals out from between the fibers of the base.

Fiber based papers have the emulsion layer coated directly onto a fiber base. Processing chemicals penetrate directly into the paper itself and longer washing cycles are required to remove them. Washing times for fiber based papers can be considerably shortened by rinsing the prints for a minute in Hypo Clearing Agent after fixing them.

Print washing setup How fast prints wash depends on the rate of water circulation over their surface. If the water isn't circulating or if prints are stacked on top of each other so water can't flow freely over their surfaces, then washing will be ineffective.

Washing setups

A Kodak tray siphon attached to the side of a large print tray makes a very good washer. It is less expensive than more elaborate models and has been used for so long by so many photographers that there are few doubts about its effectiveness. Wash only a few prints at a time to ensure good circulation over all of their surfaces. Occasionally dump the water from the tray and let it refill with fresh water.

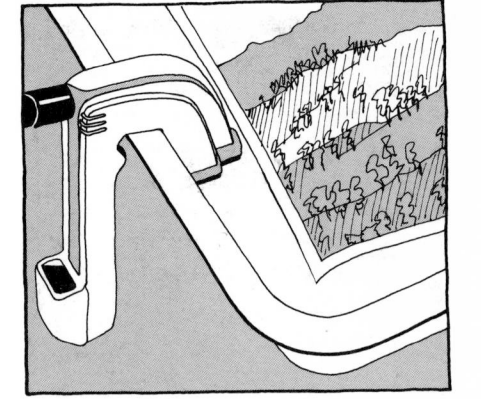

> **TIPS**
> **How do you know when washing is complete?**
>
> One way to be sure you're washing enough is to run an easy test yourself. You can buy Kodak's Hypo Test Kit at your local camera store. It contains a small bottle of solution and a plastic strip of colored squares. To test your washing:
>
> **1** After washing your prints, wipe the surface dry and put a drop of the solution on the print border (if you don't want to stain the border of a print, process an unexposed sheet of the same paper along with one of your prints and use this for the test).
>
> **2** After the solution has been on the print for 2 minutes, rinse the excess off and blot dry.
>
> **3** Use the plastic strip to judge the color of the stain left on the print by the solution. The darker the stain the more washing is required.

Step by step

24 SET TIMER

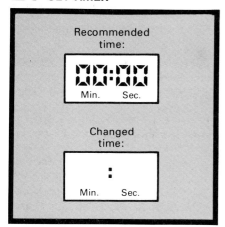

Set timer for the proper exposure indicated by your test strip.

25 LIGHTS OFF

Turn room lights off and safelights on.

26 CHECK FOCUS

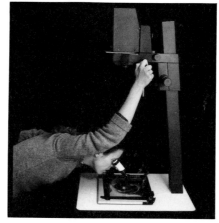

Turn enlarger lamp on and check focus of image with focusing magnifier. Make sure lens is set at same aperture used for test strip. Turn enlarger off.

27 LOAD PAPER AND EXPOSE

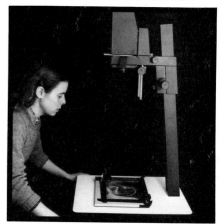

Place a full sheet of printing paper securely in easel. Wait a few seconds until enlarger stops vibrating, then make your exposure.

28 DEVELOP

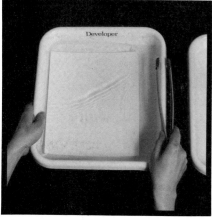

Remove paper from easel and slip it into developer. Agitate the print continually for 1½ minutes (or time written in above).

29 STOP BATH

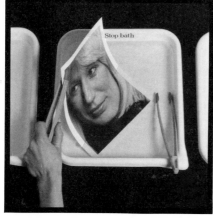

Using developer tongs, remove print from developer and drain briefly. Slip it into stop bath and agitate for 5 seconds. Remove and drain.

30 FIX

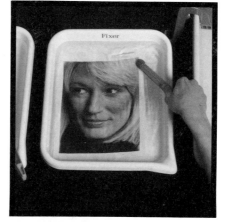

Put print into fixer and agitate it for 2 minutes. Remove and drain.

31 WASH

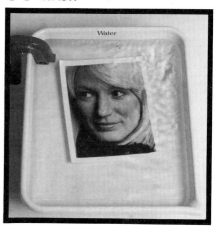

With room lights on, wash your print in running water (at between 65–75°F, 18–24°C) for 4 minutes.

The final print
Exposing and processing

STEP 3 (cont.)
The final print: Drying

Drying your prints is the final step before matting, framing, or storing them. Your goal is to dry them without causing damage to the surface, which is susceptible to mechanical damage (scratching, gouging, etc.) and also to chemical damage from contamination and water spotting.

RC papers dry flat. The glossy (F surface) type dries with a high gloss surface. Fiber-based papers, on the other hand, tend to curl when they dry. The glossy (F) surface type air dries to a smooth, but not high-gloss, surface.

You can speed your drying by first squeegeeing the excess water off the surface of your print and drying where air can circulate evenly on both sides of the prints. This will also reduce the amount of curl you will encounter with fiber-based papers.

Contamination

If prints are fixed for too long a time or if they are insufficiently washed, stains will eventually appear on the image. Even if they are perfectly fixed and washed, however, they can still be contaminated if brought into contact with other prints that were improperly fixed and washed. Prints can also be contaminated by coming in contact with objects such as blotter books or drying screens that have been contaminated by previous prints.

To reduce the possibility of contamination, always fix and wash for the recommended periods of time, use a drying screen to dry the prints, and wash the screen occasionally to remove any fixer or other chemicals that may have contaminated it. Avoid using blotter books unless you are especially careful to replace them frequently; they can soak up any chemicals left on your prints and redeposit them on the next set.

Drying your prints

Squeegeeing your print will help shorten drying times. Place the print, image side up, on a smooth surface such as a piece of glass. Wet the edge of the squeegee with water or Photo-Flo and run the squeegee smoothly over the surface of the print. Repeat in even strokes until all of the water is removed.

Blotter books are simply a series of paper blotters bound together. You insert your prints between the leaves and let them stand to dry. Since RC paper dries exceptionally well when exposed to the open air and since blotter books tend to accumulate chemicals they should only be used with completely washed prints.

Fiberglass screens are ideal for print drying. Place small blocks of wood at the corners to separate one screen from another and place RC papers face up and fiber-based papers face down (to help reduce curling) on the screens. The air will circulate freely over both sides of the print and drying will be fast and even.

Step by step

32 DRAIN PRINT

Remove print from wash and drain it briefly.

33 SQUEEGEE SETUP

Place print image side up on a smooth, clean, tilted surface that will drain into sink.

34 SQUEEGEE PRINT

With light, even strokes, squeegee the excess water off the face of the print.

35 DRYING RC PAPERS

Lay RC papers face up on a drying screen or blotter.

36 DRYING FIBER-BASED PAPERS

Fiber-based papers tend to curl toward the emulsion side when they dry; lay them face down on the drying screen, which will help reduce amount of curl.

37 FLATTEN PRINT

RC papers dry flat, but fiber-based papers need to be flattened by placing them under a weight, like a heavy book, for a day or so.

The final print
Drying

CHAPTER FIVE
Making better prints in 4 steps

As photographer Ansel Adams once said, "The negative is the score but the print is the performance." Like an orchestra conductor, you have the freedom to impose your own interpretation while making a print. Many photographers make the best print they can and then tack it up on the wall where they can look at it over a period of days and weeks. During this period they ask themselves if it can be improved. Will cropping help, or perhaps lightening dark areas or darkening light ones? If it's too flat after it dries, can it be printed with more contrast? Can the edges and corners be slightly darkened to help contain the image better? All of these questions are relevant to your interpretation; once you have answered them, it's time to make another print using the basic techniques described in this chapter.

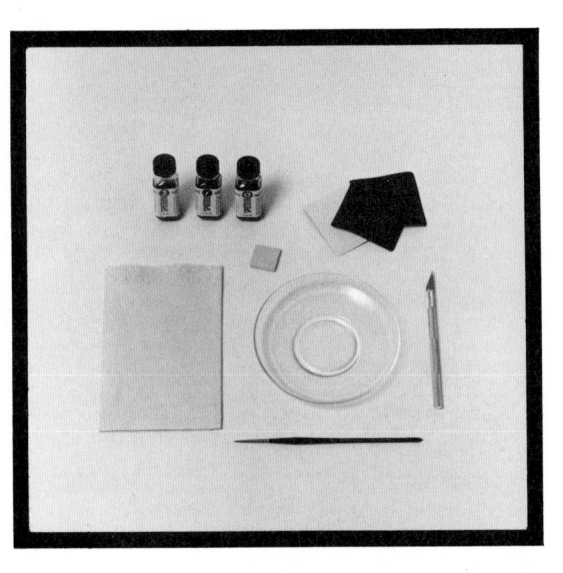

STEP 1: GETTING READY

Can your print be improved?
Equipment you'll need

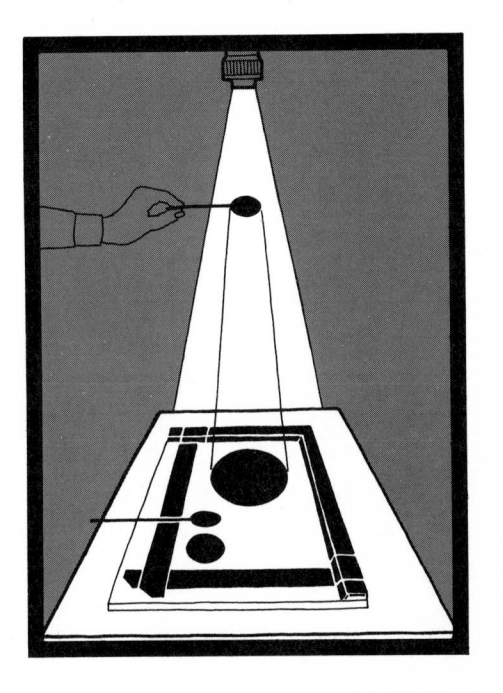

STEP 2: PRINTING CONTROLS

Cropping
Dodging to lighten dark areas
Burning to darken light areas
Controlling print contrast

STEP 3: PRINT FINISHING
Spotting
Framing your prints

STEP 4: TROUBLESHOOTING
What went wrong

STEP 1
Getting ready: Can your print be improved?

In one sense no print is ever final. As you gain experience and control, you will find that your prints change in character. If you reprint an old negative without referring to the print you made at an earlier time and compare the two prints you may be amazed at the possible difference in interpretation.

It's always best to make the best print you can and dry it before trying to evaluate the results. When prints dry they tend to get slightly darker and less contrasty than when wet. Hang the dry print where you will see it often, and see how it grows on you.

Before and after

You can change your prints subtly or dramatically with a few basic dark-room controls. Images can be cropped, their contrast changed, local areas lightened or darkened, or minor flaws corrected. You can also alter your prints with creative interpretation of the image.

In this example, the photographer first made a normal print on Grade #2 paper. The overall tones of the print were good and he could have stopped at this point. After viewing the print, however, he decided to experiment. He changed to a Grade #5 paper, which dramatically increased the contrast of the print (see p. 77); the gray tone of the water was made white and the two swimmers looked as if they were suspended.

One of these prints isn't necessarily better than the other, but the tremendous difference in the two images demonstrates how a few basic controls can help you express your ideas with your existing negatives.

Overall density Is the print too light or too dark? Prints that are too dark overall will have a loss of detail in the shadow areas and gray, veiled-looking highlights (light areas). Prints that are too light will have detail in the shadows but no detail in the highlights. The print may also lack crisp accent blacks. To correct overall density make another print using more or less exposure (see pp. 58 and 59).

Local density Is the overall density correct but some portions of the print appear either too dark or too light? If so, you can correct by dodging to lighten dark areas (see p. 72) or burning to darken light areas (see p. 74). Or you change the overall contrast of the print (see p. 76).

Composition Are there areas of the print on the edges that are not contributing to the photograph's organization or content? If so, perhaps the image should be cropped to eliminate those distracting elements (see p. 70).

Sharpness Is the print as sharp as it can be? If it lacks sharpness overall, the enlarger may have been vibrating or out of focus at the time the print was made. Check the contact sheet to see if the proof has a softness to it that you didn't notice the first time. If so, the problem was probably poor focus or camera movement at the time the picture was taken.

Edges and corners Do they look dark enough? They can appear overly light because the eye tends to perceive tones as lighter when they are next to a pure white frame, in this case the white border of the print or overmat. Sometimes, they may actually be lighter than they should be because some inexpensive enlarger lenses project stronger light through the center of the lens than through the outer portion. Consequently the print's edges and corners are underexposed compared to the center. In either case, the print may be improved by slightly burning-in the edges and corners (see p. 74).

Overall contrast Is the contrast of the print right or does it appear too harsh and contrasty or too flat? If the highlights are good but large shadow areas appear black, you might try a lower contrast paper. If the picture has a flat look, it might be improved by trying a higher contrast paper (see p. 76).

Scratches, dust, or watermarks Are there areas where you can see spots or lines? Small white spots are caused by dust on the negative or print during printing. Small black spots are caused by dust on the film before it was developed. White or black lines can be caused by scratches on the film. Scraping tongs, especially metal-toothed ones, across the surface of a developing print can also leave black scratch-like lines. Water-spots on the film can leave large circles with a dark ring on the print. All of these defects can be improved by spotting the print (see pp. 78-79). In the case of dust or watermarks on the negative you can also clean the negative and make another print.

Grain Can you see an overall grainy appearance in the print? All negatives have a grain structure that is enlarged along with the image. The amount of grain is influenced by the type of film used, your film development techniques, and by the size of the enlargements you make. If the grain in a print is objectional (sometimes it's not), try making a smaller print where the grain won't be so apparent.

STEP 1 (cont.)
Getting ready: Equipment you'll need

Some of the items you'll need for print controls you may already have, such as variable contrast paper, a two- (or four-) bladed easel; others, such as dodging paddles or burning-in cards, you can make yourself out of scrap material. Other items, such as print finishing equipment and contrast filters, can be bought at your local camera store.

Equipment for cropping

Cropping is a technique where you enlarge a portion of the image, and/or eliminate elements on the top, bottom, or sides. Cropping is done at the time the print is made (although you can crop an existing print by trimming it to any size you want) but, if possible, try to decide approximately what to crop before making the print. (Tips on cropping are given on p. 70.)

Cropping "L's" Cropping "L's" are large pieces of white cardboard cut into the shape of "L's." (See p. 52 on how to use smaller "L's" for negatives.) These larger "L's" are arranged over the print in different ways until you see how you'd like to crop the final print.

Easel Cropping can be done with an easel without movable blades, but your control increases with a two-bladed easel and is even better with one with four movable blades.

Equipment for dodging and burning

If areas of a print are too dark or too light you can change them by dodging or burning. When dodging, light is held back from a small area of the print so it will be lighter than the surrounding areas. When burning, part of the print is covered while the remaining part is exposed to more light to darken it.

Dodging paddles By cutting a piece of black cardboard into any shape you need and attaching it with tape to a thin wire you can hold back light from parts of the print without affecting the exposure of other parts. (Tips on using dodging paddles are given on p. 72.)

Burning-in cards A large piece of cardboard can be used to hold back light from any area of the print so that selected areas get more exposure. To darken an area in the center of the print you may need to cut a hole in the center of the cardboard. (Tips on burning cards are given on p. 74.)

Equipment for controlling overall contrast

The contrast of the print is controlled by the contrast of the negative and the paper grade on which it is printed. To increase or decrease your print contrast you will need several boxes of graded paper or a single box of variable contrast paper and a set of variable contrast filters (see p. 34). (Tips on controlling contrast are given on p. 76.)

Paper Variable contrast papers used without filters will give a normal (grade #2) contrast. By changing filters in the enlarger you will get a range of contrast from grade #1 to grade #5 in ½-grade steps.

Filters There are two kinds of variable contrast filters. One kind is made of optical glass and fits between the lens and the print. Because the filter is in the image path it must be of a high optical quality. The second kind is made of acetate and fits in the enlarger filter drawer between the light source and the negative. Since the projected image doesn't pass through this filter, its quality does not need to be quite so high.

Kodak Polycontrast Filter computer
Changing filters to change contrast will also change the exposure time because the filters absorb part of the light. Rather than making new test strips each time you change a filter, you can buy a Kodak Polycontrast Filter computer which can be used easily to compute any required changes in exposure.

Equipment for print finishing

Once the print is washed and dried, you may decide to frame or display it. To show it off to its best advantage the print should first be spotted and then matted.

Spotting is the process used to cover up small, but distracting, imperfections in the final print: white spots caused by dust on the negative or dark spots or scratches caused by tiny holes or scratches in the emulsion. White spots are hidden by covering them with spotting dyes, which are available in a variety of colors. A good starter kit is a set of three: neutral black, brownish black, and bluish black. By mixing these in different proportions you will be able to match almost any paper tone. You will also need a small dish, a small brush (ideally a size 00 water color brush), a sponge, and some paper towels. Dark spots can be removed with a sharp knife (etching) or covered with a white spotting color. (Tips on spotting are given on p. 78.)

Matting a print is done by sandwiching the print between a solid piece of mount board and an overmat cut out to frame the image area of the print. To cut the overmat and mount the print you'll need a straight-edge, a mat cutter, some mounting tape, and some mount board. If you want the print to last a long time, it's advisable to use acid-free museum mount board and linen tape to mount the print. These materials are available at most fine art supply stores. (Tips on matting a print are given on p. 80.)

Printing controls: Cropping

Although most photographers agree that it is better to compose an image in the viewfinder at the time a picture is taken, there are times when an image can be improved after studying the print or slide at your leisure. Cropping—trimming the edges of an image—can be used to straighten a tilted horizon, eliminate distracting elements, or enlarge small portions of the photograph when a new print is made.

Enlarging a portion of an image

If your picture seems uninteresting or dull, it may be possible to improve it by enlarging the most important part of it. By selecting a portion of the image for enlargement, pictures such as this one (right) can sometimes be improved. You should feel free to crop your pictures to any format that appeals to you.

Using cropping "L's"

To evaluate a print for cropping, first cut out two "L" shapes from a piece of paper or cardboard (their size is determined by the size of the image you are evaluating). By arranging the "L's" in various configurations, any size and shape rectangle can be formed to isolate a portion of the image. When you decide how you want to crop, mark straight lines onto the borders of the print to line up with the edges of the new cropping. Now you can either trim an existing print accordingly or make an enlarged print using the cropping guidelines to set the easel blades.

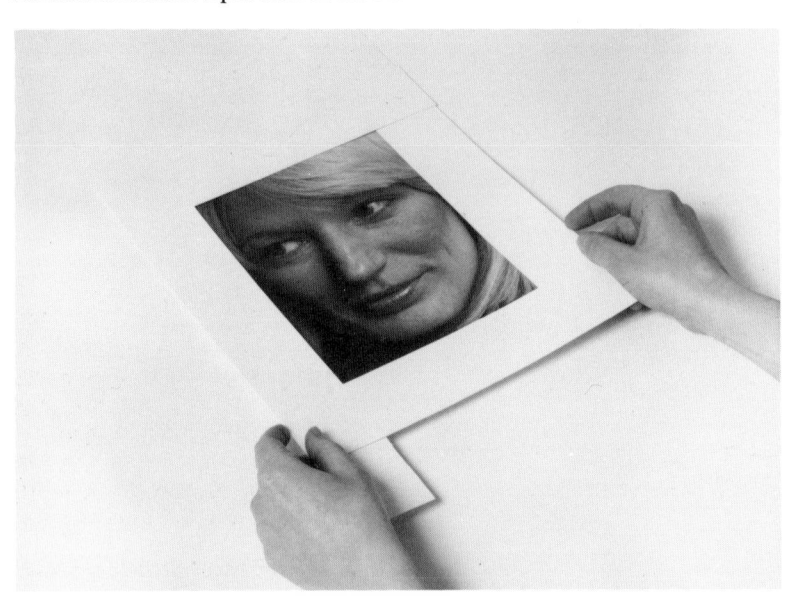

Straightening a horizon

The tilted horizon line in the photograph (right) was made level by cropping the image so that the horizon was parallel to the top and bottom of the frame (below). A small portion of the image was lost, but the result of the straightening was worth the small sacrifice.

Looking for balance

Often an image can be improved by cropping out elements that are either distracting or that don't add to the image. By removing these elements, you can improve the overall balance and make the image more interesting. The centers of interest are more obvious and attract and hold the viewer's eye.

STEP 2 (cont.)
Printing controls: Dodging to lighten dark areas

The darkness (density) of a print is a direct result of the amount of light to which it has been exposed. More light (longer exposure times or a wider aperture) darkens prints and less light (shorter time or smaller aperture) lightens them. Small areas of a print can be lightened in relation to the rest by holding back light from that area during part of the exposure while allowing light to reach the rest of the print for the full time. This is called dodging.

How dodging works

If you put your hand or a dodging paddle in the light path between the enlarger lens and the printing paper, you will block part of the light by casting a shadow on the paper. After development the area covered by the shadow will be lighter than it would have been had you not blocked the light. How light or dark the dodged area will be depends on how long you let light reach the spot before you begin dodging. The size of the dodged area depends on the size of the object used to block the light and how close it is held to the paper.

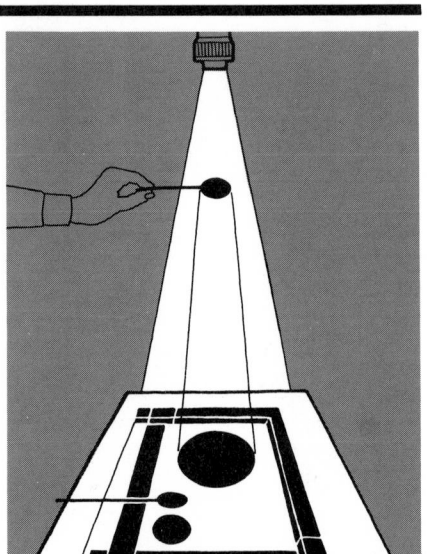

How long to dodge

If you dodge too long you may lighten the area too much and if you dodge too little it won't be light enough. Knowing exactly how long to dodge can be a trial and error process (this approach can waste a lot of paper), or you can use separate test strips to determine the best exposure times for the overall print and the dodged area.

In the photograph at top right the first test strip indicated a good overall exposure would be 15 seconds. After the print was processed and evaluated, the photographer decided that the image reflected in the mirror was too dark and that it would look better a little lighter.

A second test strip was made just of the area to be dodged. This strip indicated that this area should be exposed only 10 seconds. A second print was then made giving the print an overall exposure of 15 seconds but the image reflected in the mirror area was dodged during the final 5 seconds so it was exposed for only 10 seconds.

Blending the dodged area

Dodged areas should not be obvious in the final print; if you blend the dodged area into the surrounding area. the tones change gradually. How long you dodge (in relation to the overall exposure), how much you move the dodging tool, and how close the tool is held to the paper all control the amount of blending you will get.

In this example the dodging paddle was held very still and close to the paper when dodging. You can see a very sharp edge between the dodged and undodged area of the print; the white line shows where the dodging tool handle blocked light from reaching the print.

In this example the dodging paddle was held farther from the paper (giving a larger dodged area) and kept in continuous motion during the time it was used. The handle was also moved slowly during the exposure so that it wouldn't block light from the same area during the entire exposure. The result is a dodged area that blends in softly to the rest of the print; no line shows where the handle was.

Dodging irregular areas

When you encounter an area that is irregular in shape, you can use your hands to dodge them provided the area is on the edge of the print. If it is in the center area of the print a specially shaped dodging tool is easy to make.

In this example the photographer used the enlarger to project the image onto a piece of cardboard. The area to be dodged was traced on the cardboard with a pencil, cut out and mounted to a wire handle. This "custom" tool was then used to dodge the irregular area of the print.

When an area to be dodged is near the edge of the print you can use your hands as a dodging tool. With the negative in the enlarger but before loading paper into the easel, turn on the enlarger and try to arrange your hand and fingers to cast the shadow you want. After you have practiced, load the easel and make the print.

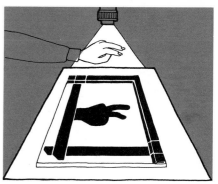

Printing controls: Burning to darken light areas

Burning, like dodging, is a technique to change the darkness of one part of a print while leaving the balance unchanged. In burning, extra light reaches part of the print while not changing the exposure for the rest.

How burning works

Once the overall exposure for a print is determined using a test strip, the print is exposed for that length of time. Those portions that may still be too light are darkened by adding additional exposure while using a card to hold back light from the balance of the print.

The size of the burned area is controlled by the size of the card (or the opening cut in the card) used and how far it is held from the paper. The area burned in is smaller when the card is held close, and larger when held farther away from the paper.

The darkness of the burned-in area is determined by how long the area is burned. An area burned longer will be darker than an area burned for a shorter period.

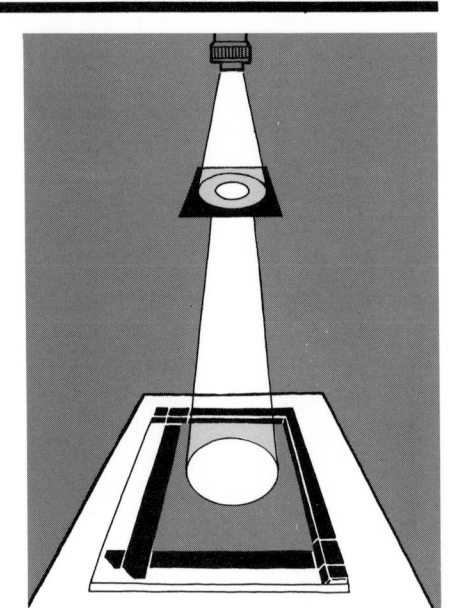

How long to burn

When burning, the most efficient way to determine the best exposure time is to use a test strip as a guide. Quite often when burning major areas such as the sky to make the clouds stand out you can use your initial test strip to give you a time. If the strip was placed right you may have covered both the foreground and sky areas. The strip may therefore tell you that the foreground should be exposed for 10 seconds and the sky for 60 seconds. If you cannot place your strip to give exposure information for both the normal exposure and a burned-in area, you should then make a separate strip to give you guidance for burning.

A test strip of the original photograph (top right) showed that the foreground should be exposed for 8 seconds.

The test strip also indicated that the sky would look dramatic if it were darkened by burning it for an additional 24 seconds (for a total of 32 seconds of exposure—the initial 8 plus the 24-second burn). The final result is shown at bottom right.

64 32 16 8 4 2

Blending in the burned-in area

Burned-in areas should not appear obvious in the print. You can smoothly blend the burned-in area into the unburned area by moving the burning card during the entire exposure. The blend will also be smoother if the card is not held too close to the paper during the exposure.

In this example the burning card was held very close to the paper and not moved during the exposure. The line separating the burned-in area from the rest of the print is very sharp and very obvious.

In this example the burning-in card was held farther from the paper (making the burned-in area larger) and kept in motion during the exposure. The movement of the card resulted in the line between the burned and unburned areas being a gradually changing blend rather than a sharp, distinct line.

Burning areas in the center of the print

When the area to be burned lies on the edges of the print, a piece of cardboard cut from an old box of photographic paper will suffice as a burning card. When the area is irregular or in the center of the print, however, an opening should be cut in the card.

In this photograph the face in the center of the picture was too light, so the photographer cut an opening in a piece of black cardboard. After exposing the entire print for a good overall density, the photographer then used the card to hold back the light from most of the print while allowing it to reach the face through the hole cut in the card.

If the shape to be burned is irregular, you can place a piece of cardboard on the easel, turn on the enlarger and trace the area onto the cardboard. Use an X-acto knife to cut out the hole outlined on the card and use it to burn in the irregular shaped area.

Printing controls
Burning

Printing controls: Controlling print contrast

Black-and-white photographs usually contain a continuous series of tones ranging from pure white to pure black, and all of the gray tones in between these two extremes. When the photograph contains all of these tones, it is considered "normal" in contrast. When it contains just the extremes (i.e., pure black and pure white), it is considered to be "high contrast." When it contains just the mid-tones and neither of the extremes it is "low contrast." Although the contrast of the negative (and the scene you photographed) have the most influence on your print's contrast, you can control it to some extent by your choice of paper, either graded paper or variable contrast paper in conjunction with a set of variable contrast filters.

What is contrast?

Normal contrast A normal contrast print (or negative) has a full range of tones ranging from pure white to pure black. It also has a good distribution of the middle gray tones as can be seen in this example.

Low contrast Low-contrast prints tend to have a flat appearance and emphasize the middle grays. There is usually an absence of pure blacks and pure whites in a low-contrast print.

High contrast Prints with a high contrast have a harsh appearance. The print has very few middle grays and the pure blacks and pure whites tend to predominate.

Controlling print contrast with graded or variable contrast paper

Graded papers are sold in boxes of individual contrast grades. The number of contrast grades available varies depending on the paper type and manufacturer, but the most common grades are 1 (low contrast) 2, 3, 4, and 5 (high contrast). With variable contrast papers you need to buy only one box of paper and a set of filters; this reduces your investment and gives you a greater choice of contrasts. The filters used with the papers come in 1, 1½, 2, 2½, 3, 3½, and 4 steps. The ½ steps give you more choices than the full steps found in graded papers.

In the series of photographs to the right, a "normal" negative was printed on graded papers ranging from grade 1 to grade 4. As the grade of the paper increases, so does the contrast of the print.

Grade 1 A "normal negative" printed on a low-grade (1) paper (or using a grade 1 filter) gives the print a flat appearance with an overall gray look. Notice the absence of sharp, crisp blacks in the print.

Grade 2 The same "normal" negative printed on a grade 2 paper gives a good tonal scale. Both pure whites and crisp blacks appear in the print.

Grade 3 When printed onto a grade 3 paper (or using a grade 3 filter) the print looks harsh. The shadow areas appear distinctly too black and detail begins to get lost.

Grade 4 On grade 4 paper, the print is extremely harsh and detail begins to get lost even in the middle gray areas of the print.

STEP 3
Print finishing: Spotting

No matter how careful you try to be, most prints end up with a few small light or dark spots on their surface. These spots are usually due to dust particles that adhered to your film or paper. Distracting spots can be lessened or eliminated by spotting them out—darkening light spots or lines, lightening dark ones. Light specks are the most common, and fortunately the easiest to fix. Dark specks are more difficult but can be improved. Your goal should be to do the minimum amount of spotting to make the offending spot inconspicuous from normal print viewing distance. Too much spotting can leave the print looking worse than when you started.

Darkening white spots

Little white specks and squiggles on your prints are usually caused by dust particles on the negative or paper during printing. These particles block the light from the paper, leaving a white image of the dust particle on the print. You can darken the spot by applying a dye to the print surface (see below). Waterspots on the negative can cause larger light-toned spots on the print that sometimes can be improved by spotting the print, but are better cured by rewashing the negative or cleaning it with film cleaner, then reprinting.

The key to a good spotting job is to match the darkness and color of the area surrounding the spot. Mix your colors in a white dish, dilute if needed with water, and apply gradually to the print with the tip of a small brush. Work under a bright light and, if necessary, use a magnifying glass.

Materials needed for spotting
- Spotone: No. 3 (neutral black)
- Watercolor brush size 00
- Small white dish
- Small sponge or cloth
- Water

Removing dark spots

Dark spots are caused by two different things: scratches on the negative and dust specks that adhere to the film when it was exposed in the camera. Each results in a blank spot on the negative that lets light pass unchecked onto the print. Abrasion of the print surface can also sometimes cause dark scratches. Black marks are distracting when they occur in the sky or other light areas of the print. Here are three different ways to remove these dark spots:

Etch them off Dark specks can be scraped from the print's emulsion with the tip of a very sharp X-acto blade or single-edged razor blade. Practice on a scrap print, taking off only a very thin layer of emulsion at a time to gradually lighten the spot. Do not try to scrape the dark spot off in a single stroke or you are likely to gouge through to the paper base. This is the

technique used by most photographers for small specks even though the scraped surface will show up on glossy prints.

Bleach them out A photographic bleach such as Spot Off can be used to remove a black spot entirely or to lighten an area slightly. Mix the product as directed by the manufacturer to get the effect you want. Bleaching does not affect the surface finish of the print, but, depending on the spot, can be tricky to control.

Cover them up Kodak Spotting Color in white (darkened with a little black, if necessary) can be applied to the print's surface with a small brush. This may leave a dull surface finish that is relatively noticeable on close examination. If you don't like the way it looks, wipe it off and try one of the other methods.

Step by step

1 TEST COLOR OF DYE

Place a drop of neutral black Spotone on a small, white plate. Spread a bit on print margin or on scrap print. Compare dye color and print color.

2 TEST DARKNESS OF DYE

Find the darkest print area in which there is a white spot you want to remove. Moisten the brush with undiluted dye, wipe off excess on a cloth and test again in margin.

3 APPLY DYE TO PRINT

Pick up some dye with the tip of your brush, wipe off excess, and apply a small amount to print.

4 EVALUATE

Examine the spot to make sure it is not getting too dark. Work on it little by little, until the tone of the spotted area matches the neighboring area.

TIPS

If dye color is significantly different from print color, you can mix the neutral black with brown black or blue black dye.

You can let the Spotone dry on the dish for later use, then pick up some color with a wet brush.

TIPS

The dye should be slightly lighter than the area surrounding the spot. Dilute with water if the dye is too dark. You can add several coats of dye, gradually darkening a spot, but it is very difficult to lighten a spot once it is too dark. The dye will look slightly darker when dry than when wet.

Work from the darkest areas of the print to the lightest ones rather than skipping back and forth from light to dark areas.

TIPS

Practice a few times on a scrap print, rather than starting with your best print.

Work from the center of the spot out to avoid darkening the area surrounding the spot. Apply the dye in tiny dabs rather than large brush strokes.

If the imperfection is hairline shaped don't try to draw the brush along the length of the line. Instead treat the line as a series of dots, and work segment by segment along the line. Often you won't need to eliminate the entire line, just break it into segments that become inconspicuous.

TIPS

If you made the spot too dark, there are a few possible solutions: Use a sharp X-acto blade and scrape off the dye bit by bit (see removing dark spots, above). Moisten a clean brush or Q-tip in some water, apply to the too-dark area, both with dry tissue. This should remove the dye a little. Use a dry or watercolor type spotting color and paint a lighter tone over the mark. When done for the day, reshape your brush into a fine point. It will then dry that way and be ready to use next time. Unshaped brushes tend to bush out.

Print finishing
Spotting

Framing a print for hanging is the final step in photography and presents your work to its best advantage. In most cases, a framed print will look better if it is first mounted and overmatted.

The mounting process involves attaching the back of a print to a heavy-weight piece of cardboard. Overmatting (or matting) a print involves cutting an opening the size of the print's image area in a larger piece of mount board. The overmat keeps the surface of the print from touching the glass in a frame, which is desirable because under pressure the print may adhere to the surface of the glass.

For both matting and mounting, the ideal material for valued prints is archival or museum-quality, high-cellulose mount boards because they are free of the acidity that may eventually discolor a print. For short-term display or less valued prints, ordinary mounting boards are less expensive and widely available in art and framing supply stores.

TIPS
Matting, mounting, and framing

■ There is a difference between mathematically centering a print in the overmat with equal borders on all sides and "visually" centering it. Many prints look best with the top and side borders of equal width and a slightly wider bottom border.

■ Never use window spray to clean the frame glass; the chemicals can harm your print.

■ When laying out the "window" in your overmat, you can cut the opening any size you want. In many cases, however, you may want to have it slightly smaller than the image area to give the image a sharp, even edge when it's matted.

■ Mount board is available in 2-ply and 4-ply weights. Either works well for matting; the 2-ply is less expensive and the 4-ply gives a more noticeable edge when cut with a beveled mat knife.

Choosing a frame

Custom framing can be quite expensive, so many photographers use frames they can assemble themselves. The two most popular types are clear plastic "boxes" and aluminum frame sections that can be assembled with a screwdriver. Plastic "box" frames are available in standard sizes of 5 × 7, 8 × 10, 11 × 14, 16 × 20, 20 × 24, and 24 × 30. Aluminum frame sections are packaged in pairs of equal length and two pairs can make almost any size frame.

Plastic frames Of the ready-made frames, plastic "box" frames are the simplest and quickest to use. They are clear, acrylic boxes with an open back into which a slightly smaller cardboard box slips to hold the picture in place. All you have to do is mat your photograph, or attach it to the inner cardboard box if you choose not to mat it, then slip it into the frame.

Metal frames Metal frames are quite contemporary, and require only a screwdriver to assemble. The Nielsen frame, shown here, is held together by metal angles which slip into the slot at the back of the frame. Glass, mat, and backing are held securely against the lip of the frame by metal springs inserted after the frame is assembled. Pre-cut lengths are sold, two to a package, along with instructions and assembly hardware.

Step by step

1 DETERMINE FRAME SIZE

Measure image area of print and add the border you want. A print with a 9 × 7 image, 2-inch borders on top and sides, and 3 inches on bottom would require a frame 13 × 12.

2 CUT MOUNT BOARD

Cut two pieces of mount board to fit the frame you have chosen. One will be used for the backing and the other for the overmat.

3 MEASURE AND CUT WINDOW

On the back side of the board used for the overmat, lay out the area to be cut for the "window." Cut it out using a mat knife.

4 POSITION PRINT

Align the backing board and overmat (you might hinge them first to keep them aligned) and position the print within the window area.

5 MOUNT THE PRINT

Cut four pieces of tape (linen is preferable) and use them to hinge the print to the board.

6 CLEAN GLASS AND ASSEMBLE

Clean the glass with a lint-free towel and plain water. Lay the glass on top of the print and overmat and insert into frame. Complete frame assembly.

Print finishing
Framing your prints

Troubleshooting: What went wrong

One of the reasons photography can be enjoyable for a lifetime is because of the almost infinite variety of ways images can be modified, improved, changed, and controlled. Most likely, you, like other photographers, will encounter a seemingly endless series of "problems" that need to be solved for your photographs to improve. Large mistakes, like developing an unexposed roll of film because it got mixed up with your exposed rolls, are almost as common as small mistakes, like not agitating the tank properly when developing your film. On this and the following pages is a guide to the most frequently encountered problems and steps to solving them.

Film stuck together during development

Negative characteristics
The negatives will have large, irregular-shaped areas that are not developed.

Cause When film was wound onto the developing reel, two sections of it were wound onto the same spiral, so that it was not separated by the reel. Developer was not able to reach this area and hence it is left undeveloped.

Solution Always test periodically when winding the film to be sure it's winding smoothly. (See p. 24 on how to test.)

No image at all

After developing your film you may discover that some or all of the frames lack any image. They may be either entirely clear or completely black. The characteristics of the negative help to identify the cause of this problem.

Negative characteristic Both image area and edges are clear (except for film frame numbers).

Cause The film was not exposed to light. If the entire roll is unexposed, the most common cause was that the film was never put into the camera. If only single frames have this problem, then it could have been caused by the flash failing to fire, very little exposure given a scene in very dim light, the shutter being tripped with the lens cap on the camera, or a mechanical problem with the camera's shutter or mirror.

Negative characteristic Image area is black but edges of the film frame are clear (except for film frame numbers and manufacturer's name).

Cause The film was massively overexposed to light through the lens and shutter while in the camera. Either the film speed dial was set incorrectly, or the shutter was set on the "B" setting at the time the picture was taken. It could also have been caused by the mechanical failure of the camera's aperture or shutter.

Negative characteristic Both image area and film edges are black.

Cause The film was overexposed to light but not through the lens and shutter. The most likely cause was that the camera back was opened inadvertently (this will normally overexpose only part of the roll). If the entire roll is black, then the film was probably exposed when it was being loaded into the film tank.

Negative too light, dark, flat, or contrasty

Both the exposure of your film and its development affect the density (how light or dark) and the contrast (the range between the lightest and darkest parts) of your negatives. Negatives that are too dark can be caused by either overexposure or overdevelopment. Negatives that are too light can be caused by either underexposure or underdevelopment.

The proof sheet at right shows a series of photographs made from negatives that have been exposed and developed differently. The row of underdeveloped images appears flat with little contrast between shadows and highlights compared to the overdeveloped row, which has very high contrast. The images from the vertical row that was underexposed are too dark and the images from the row that was overexposed are too light. The ideal negative is the one that has been both normally exposed and normally developed. You can make acceptable prints from most of the others if you change paper grades (see p. 76), but they will take more work and will not be quite as good.

	Underexposure	Normal exposure	Overexposure
Underdevelopment		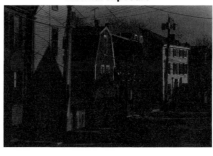	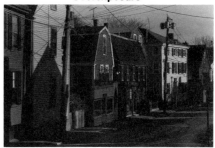
Normal development	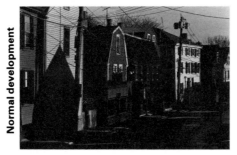	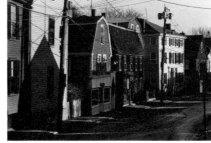	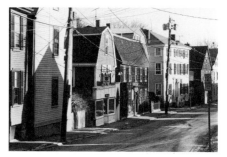
Overdevelopment			

Troubleshooting: What went wrong

Image reversed

Print characteristics The image will be reversed left to right when compared to the proof sheet. Words or letters in the image will appear reversed.

Cause The negative was not put into the carrier with the emulsion-side down.

Solution Always be sure to locate the emulsion side (see p. 42) when loading the negative into the carrier.

Fingerprints

Negative and print characteristics
Negatives will show oily fingerprints when held up to the light at an angle. These fingerprints may appear on your prints as smudged areas with a lack of sharpness and uneven density; they normally appear as white areas in the image area or as stains in the margin.

Cause Fingerprints on negatives are caused by holding the film improperly. In time fingerprints can even permanently damage the emulsion; remove fingerprints immediately with film cleaner and a soft, lint-free cloth. Fingerprints on prints are normally caused by having a fixer residue on your fingers when handling undeveloped prints.

Solution Always rinse hands well and dry before handling fresh sheets of paper. Handle negatives only by the edges.

Fogging

Negative and print characteristics

Both will show a loss of contrast and will have an overall gray appearance, especially in the highlight areas of the print. Negatives will occasionally be light-streaked only in parts.

Cause Fogging is caused by light leaking into the camera film tank or darkroom when light-sensitive film and paper are exposed. It can also be caused by safelights that are too close to the enlarger or processing trays (or that have a wrong or bad filter). Film should be handled only in complete darkness and printing paper only in a completely lightproof room illuminated with the proper safelight and filter.

Solution To be sure your safelights aren't fogging the paper, run the test opposite.

Safelight test

Printing paper has a characteristic response to light that makes it relatively more sensitive to additional light after it has been partially exposed. To check properly how light-tight your darkroom is, use paper that has already been sufficiently exposed to have passed its exposure "threshold" and is at its most sensitive:

1 Focus the enlarger on the easel using a standard negative. Have the easel blades cover a margin of the paper so it will not be exposed when the print is made.

2 Expose Print #1 as you would normally WITH THE SAFELIGHTS ON and develop and fix it as recommended.

3 Expose Print #2 in the same exact way except HAVE THE SAFELIGHTS OFF. Develop and fix it as you did Print #1.

4 Expose Print #3 in the same way WITH THE SAFELIGHTS OFF. Before developing put the print where the developer tray normally is and cover three-quarters of it with an opaque card. Turn the safelights on and expose the exposed strip for 1 minute, move the card to expose another strip and expose that for 2 minutes, move it again and expose the new strip for 4 minutes. The test strip will have four exposures of 7, 3, 1, and 0 minutes total exposure. Now develop and fix this print as you did #1 and #2.

After the prints are dry they should be identical in both the shadow and highlight areas as well as the white borders. If print #1 has a lower contrast or dirty highlight areas in comparison with print #2, there is a problem with the safelights. You should check their wattage, the condition of the filter, and the distance to the enlarger and developer tray. If print #3 differs from #2 in any of the time periods tested, it will give you the maximum time a print can be exposed to the safelight. You will also note that on print #3 the corresponding margin is unaffected, which proves that paper becomes more sensitive to additional exposure after crossing its threshold.

Troubleshooting: What went wrong

Agitation streaks

Print and negative characteristics
Dark areas on the negative (light areas on the print) extending into the print area from the holes in the film edges.

Cause These agitation streaks are caused by overagitating the film during development. The overagitation causes developer to flow rapidly through the film sprocket holes, over-developing the immediate area around them. This makes this area denser (darker) on the film than the rest of the negative and these streaks show up as light areas extending into the image on the print.

Solution Sometimes the agitation marks can be cropped out of the image or the edges can be given extra exposure to make them less obvious. The best solution, however, is to develop better agitation techniques. (See p. 26.)

Air bells

Print and negative characteristics
The negative will have almost invisible, small light spots surrounded by a dark ring. The print will show these enlarged with the tones reversed so they appear as small dark spots surrounded by a lighter ring.

Cause When the developer is poured into the developing tank, small air bubbles can cling to the surface of the film. If the tank is not rapped sharply against the working surface prior to agitation, these bubbles may not be dislodged. The air bubble prevents the developer from reaching the film under it (causing the small light spot on the negative) and the developer flowing over the surface of the bubble increases the development in the areas immediately surrounding the bubble (causing the dark ring on the negative).

Solution None with existing negatives. On future rolls be sure to rap the tank sharply to dislodge air bubbles clinging to the film after pouring in the developer.

Scratches

Print and negative characteristics
Negative scratches will appear as dark or light lines on both the negative and prints. Scratches or abrasions on the prints will appear as dark or rough areas and in some cases as white lines if the emulsion is scratched all the way through.

Causes Negatives are normally scratched when being advanced or rewound in the camera. The pressure plate on the back of the camera should be cleaned periodically to remove dust. Film cassettes should always be carried in their film cans to prevent grit from getting on the slot where the film comes out so it won't scratch the film. Negatives can also be scratched in the darkroom by pulling them through the negative carrier. Always open the carrier before sliding the film to center it or to move to a new frame.

Prints can be scratched by sharp edges on the print tongs. They can also be abraded if not stored properly after processing.

Solution Handle paper and negatives carefully. Store negatives in preservers and interleave valuable prints with smooth, good-quality paper. Don't pull a sheet of paper out of the middle of a pile or a negative through an unopened negative carrier.

Unsharp images

Negative and print characteristics
It's hard to tell from the negative or proof sheet if a 35mm negative is sharp unless the blur or softness is extreme. It is usually when a print is made that the lack of sharpness becomes apparent.

Cause Most unsharp images are caused by poor focusing, camera or subject movement, or insufficient depth of field at the time the picture was made. It can also be caused by poor focus of the enlarger or movement of the enlarger head at the time the print was exposed.

Solution If the image is soft or blurred all over, it might be worth making another print after carefully testing the enlarger focus to determine whether the negative was at fault. Many negatives will "pop" or buckle enough to throw parts of them out of focus if they get hot from the enlarger light. It helps to focus relatively quickly to avoid problems that result from this buckling.

Index